REDHILL &
REIGATE

THROUGH TIME

Roy Douglas

AMBERLEY

Acknowledgements

The author has received much help in the production of this book. His wife Jean has kindly read and criticised the manuscript and has patiently put up with his all-too-frequent panics. His daughter Alison Grover who, unlike the author, really understands the possibilities and vagaries of computers, has helped enormously with the technical side.

Staff and helpers at several institutions have cast light in dark places. These include people working at Surrey History Centre, Woking at Reigate and Redhill public libraries at St Mary Magdalene Church at Reigate including the Cranston Library and at Reigate Grammar School.

Peter Burgess has greatly helped in two ways. He is a representative of the Wealden Cave and Mine Society which offers opportunities for people to visit the extraordinary caves leading from Tunnel Road, and also the 'Barons' Cave' associated with Reigate Castle. He is also Honorary Archivist of Reigate Grammar School, and has sent the author some very useful old photographs which are included in the text of this book.

The author also thanks the image copyright owners who have permitted him to use their material. Many of the illustrations are reproduced by permission of Surrey Historical Centre and several from Reigate Grammar School's archives. If he has accidentally missed any other copyrights, he asks the owner to contact him via the publisher.

Several members of staff at Amberley Publishing deserve both thanks and apologies for their active interest in the book and their tolerance when the manuscript didn't appear as soon as originally intended.

First published 2016

Amberley Publishing
The Hill, Stroud, Gloucestershire, GL5 4EP
www.amberley-books.com

Copyright © Roy Douglas, 2016

The right of Roy Douglas to be identified as the
Author of this work has been asserted in accordance with
the Copyrights, Designs and Patents Act 1988.

ISBN 978 1 4456 3323 7 (print)
ISBN 978 1 4456 3337 4 (ebook)

British Library Cataloguing in Publication Data.
A catalogue record for this book is available from the British Library.

Typesetting by Amberley Publishing.
Printed in Great Britain.

Introduction

Reigate and Redhill are two adjacent Surrey towns with similar populations, around 23,000 in Reigate, and around 18,000 in Redhill, lying within a few miles of the junction between the M25 and M23 motorways. The centres of the towns are just over 2 miles apart, but the residential areas blur into each other so thoroughly that they form one conurbation and the visitor will often be uncertain whether he is in one place or the other. Both send many commuters to London every day, yet neither – and particularly Reigate – is truly a suburb. Both have developed enormously in the past couple of centuries, largely as a result of their proximity to London. The 1801 census listed just 923 people living in Reigate Borough and 1,323 living in 'Reigate Foreign' – an extensive rural area of which modern Redhill was but one part.

Although the two towns are closely linked physically, their centres are very different. If we could imagine a person living at the beginning of Victoria's reign in 1837, visiting the modern towns he or she would find much in central Reigate which was still familiar, but would recognise nothing at all in the middle of Redhill. Indeed, a person who knew Redhill a century after Victoria's accession would have difficulty in recognising the modern town. This difference derives from the different histories of the two places. Reigate, as we shall see, is a very old place, mentioned, (though under a different name) in the Domesday Book of 1086, with a medieval parish church and vestiges of other medieval structures. Quite a lot of buildings in the present town contain features deriving from the eighteenth century or earlier. Redhill, by contrast, is essentially a product of the railways, though there are a few earlier buildings. The name Redhill only came to be applied to the general area of the present town when the nineteenth century was well advanced.

The railways profoundly affected the character of both places. When the line from London to Brighton was being planned, around 1840–41, the natural course for the north–south link would have been through Reigate, following roughly the line of the old coach route. There was local objection, and the line was taken further east, along the present route through Redhill. A few years later an east–west railway line was built, which would eventually run through Reading, Guildford, Dorking and Reigate to Redhill, and thence further east. In the Reigate area, this ran some distance north of the main west–east road, the present A25, and apparently encountered less local difficulty. The upshot was that Reigate's rail communications to London and

Brighton were indirect, via Redhill, which became the more industrial place. Both towns grew rapidly, but they exhibited, and still exhibit, different characters.

The first known reference to Reigate is in the Domesday Book of 1086, under the name 'Cherchefelle'. Some authorities interpret this as 'church field', but others prefer a very different etymology – 'the open space by the hill'. It had belonged to Edith, wife of Edward the Confessor. In later medieval times, Reigate became a place of some importance, with a castle, a substantial parish church and a priory. Long after that it remained a parliamentary borough – though latterly a 'rotten' one – returning two MPs until 1832. It even just scraped through the Reform Act of that year, though it had fewer than 200 electors. Reigate still returned a single member until 1867. There are many buildings in the town deriving from the eighteenth century or earlier. Inevitably, a lot of the old buildings recorded in illustrations to this book have since disappeared, but a number of the nineteenth-century scenes are recognisable today despite the different garments worn and means of transport used.

Redhill is very different. There are indeed a few buildings remaining which antedate the railways, but the large majority are much more recent. The main part of the town has continued to change, and enormous development took place in the last few decades.

A plea from the author! In the course of writing this book, he made many visits to both towns. A few of the interesting buildings and other structures are labelled in a way which the modern visitor will notice, but the large majority of buildings of historical importance, and places where important buildings existed in the past, are not marked at all. To give but one of many examples from each town, the site of the important coaching inn, the White Hart, in Bell Street, Reigate, and the site of the original railway station in Redhill, which eventually led to the development of the whole town, are not marked at all and the author had some difficulty in finding where they had been located. It would surely add to the civic pride of residents and to the interest of visitors if either the local authority or private individuals set out to mark such places with wall plaques.

Reigate Parish Church

By far the oldest building in the Reigate and Redhill area which still retains something of its medieval appearance and function is Reigate Parish Church, located some distance to the east of the town's present-day centre. Dedicated to St Mary Magdalene, this was once the parish church of the whole area. The date of origin is uncertain, and may antedate the Conquest (though it is not mentioned in the Domesday Book). One author, W. Hooper, in his book *Reigate: It's Story Through The Ages,* described it as a 'complex of various styles of Gothic architecture [which] suffered badly from 19th Century restoration'. The external appearance does not appear to have changed greatly for several centuries. The illustrations on this page are an old print, probably eighteenth century, and a photograph from around 1890 (copyright of Surrey History Centre).

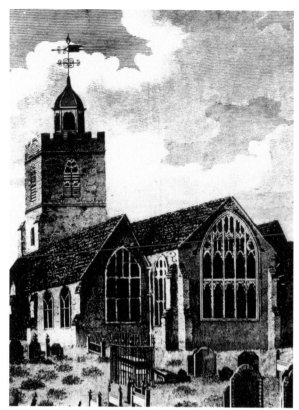

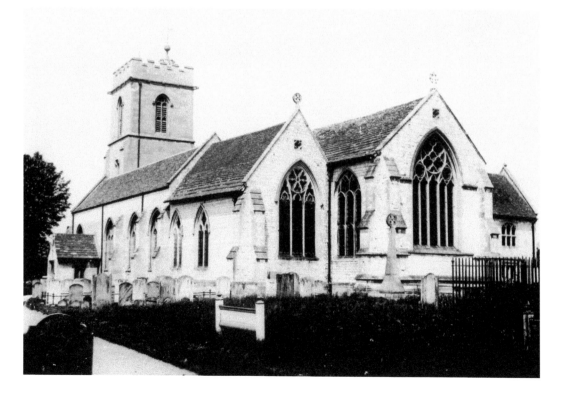

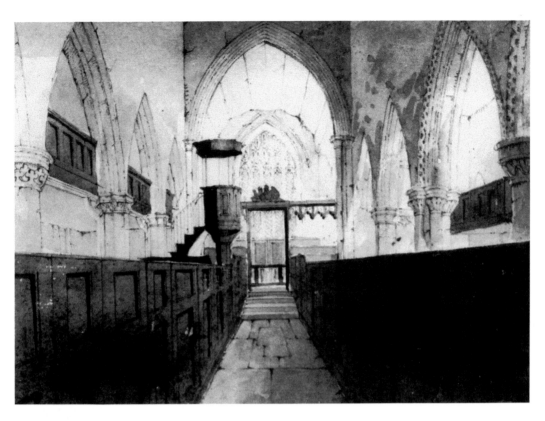

Reigate Parish Church

A modern photograph of the church does not show great change in the external appearance. There have however been big changes in the interior. The top illustration (copyright of Surrey History Centre) is a sketch of around 1823. There are conspicuous box pews, for which wealthier members of the congregation would pay rent.

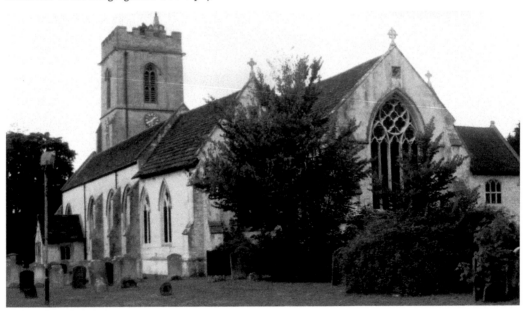

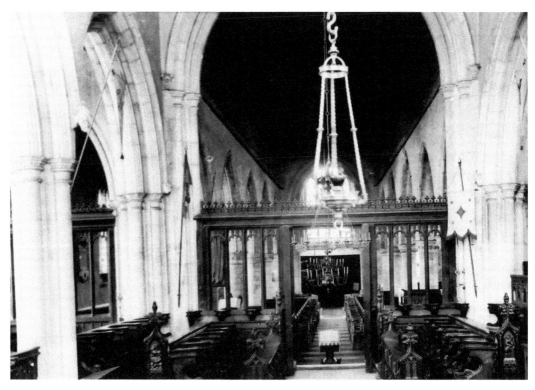

Reigate Parish Church

By around 1890, the date of the first photograph (copyright of Surrey History Centre), substantial changes had taken place in the church's interior, particularly in the seating arrangements and improved illumination. The population of Reigate was increasing rapidly and it was necessary to make facilities for a much larger congregation. In the contemporary photograph, modern seating has entirely replaced pews and a screen allows for visual illustration.

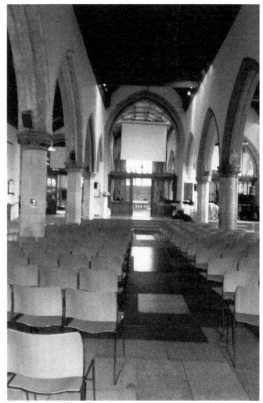

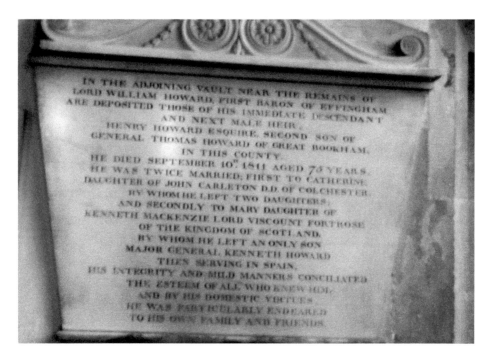

IN THE ADJOINING VAULT NEAR THE REMAINS OF
LORD WILLIAM HOWARD, FIRST BARON OF EFFINGHAM
ARE DEPOSITED THOSE OF HIS IMMEDIATE DESCENDANT
AND NEXT MALE HEIR,
HENRY HOWARD ESQUIRE, SECOND SON OF
GENERAL THOMAS HOWARD OF GREAT BOOKHAM,
IN THIS COUNTY,
HE DIED SEPTEMBER 10ᵗʰ 1811 AGED 75 YEARS.
HE WAS TWICE MARRIED; FIRST TO CATHERINE
DAUGHTER OF JOHN CARLETON D.D. OF COLCHESTER
BY WHOM HE LEFT TWO DAUGHTERS,
AND SECONDLY TO MARY DAUGHTER OF
KENNETH MACKENZIE LORD VISCOUNT FORTROSE
OF THE KINGDOM OF SCOTLAND,
BY WHOM HE LEFT AN ONLY SON
MAJOR GENERAL KENNETH HOWARD
THEN SERVING IN SPAIN.
HIS INTEGRITY AND MILD MANNERS CONCILIATED
THE ESTEEM OF ALL WHO KNEW HIM,
AND BY HIS DOMESTIC VIRTUES
HE WAS PARTICULARLY ENDEARED
TO HIS OWN FAMILY AND FRIENDS.

Reigate Parish Church

Many monuments to the dead are found here, as in most old parish churches. There are several in the interior of the church, largely devoted to members of local wealthy families, like the first illustration. In the churchyard, many humbler people are buried. The lower illustration commemorates a mental patient at a mental hospital, then styled as an asylum, at Earlswood in the Redhill area. He is described as 'for 52 years a happy inmate'. One hopes that he was.

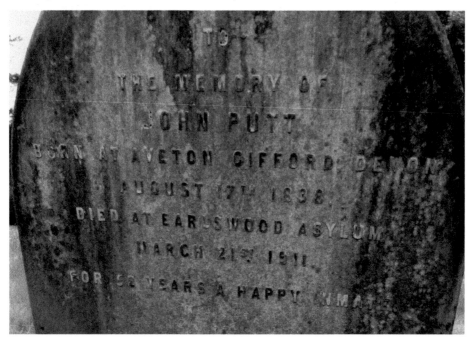

TO
THE MEMORY OF
JOHN PUTT
BORN AT AVETON GIFFORD DEVON
AUGUST 17ᵗʰ 1838.
DIED AT EARLSWOOD ASYLUM
MARCH 21ˢᵗ 1911.
FOR 52 YEARS A HAPPY INMATE

Cranston Library

The most remarkable feature of Reigate Parish Church is the Cranston Library. Andrew Cranston, who came from Scotland, was vicar of Reigate at the turn of the seventeenth and eighteenth century. The library which he founded in 1701 is still in its original room above the vestry. It appears to be the oldest public lending library and continued to function as such until 1925. Anyone resident in the parish, and gentlemen and clergy from nearby parishes, were authorised to borrow. Cranston began the library with books from his own collection and actively solicited many others. Additions have been made from time to time ever since. Many, but by no means all, of the books are on theological and related subjects. The first illustration is a sketch of the exterior, dated 1823 (copyright of Surrey History Centre). The second shows the door to the library, probably with the original painting of 1701. The Latin motto may be translated as 'food of the spirit'.

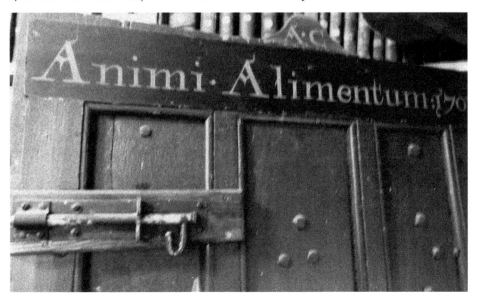

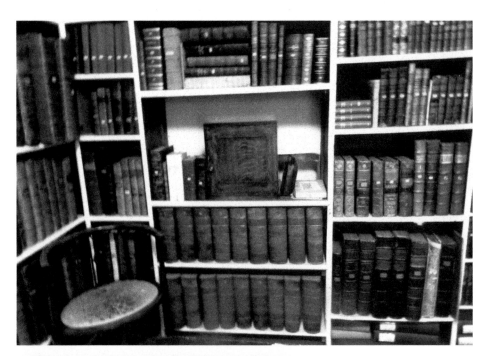

Cranston Library

Some of the books in the Cranston Library are seen in the region of what was once the fireplace. The library window is a curious mixture. The top course contains some medieval stained glass; the lower course is a product of one of the nineteenth-century restorations.

Reigate Castle

The castle was apparently commenced by William de Warrenne (variously spelt), Earl of Surrey, in the late eleventh century. Nothing remains in place of the building, though no doubt much of the stonework and perhaps timbers as well, have been used in the modern town. The castle played a major part in the origin of Reigate, which seems originally to have come into existence as a distinct town in order to satisfy the castle's needs. The top photograph (copyright of Surrey History Centre), dated around 1889 and taken from the castle grounds, brings out the close link. The second illustration (copyright of Surrey History Centre) is a copy of an engraving, said to be dated 1534 or 1536, but there is doubt whether this is based on an authentic portrayal of the castle as it really looked.

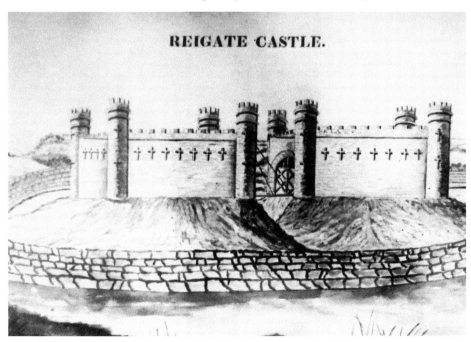

REIGATE CASTLE.

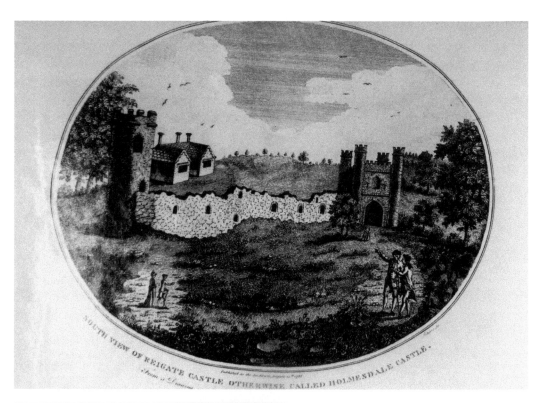

SOUTH VIEW OF REIGATE CASTLE OTHERWISE CALLED HOLMESDALE CASTLE.
from a drawing

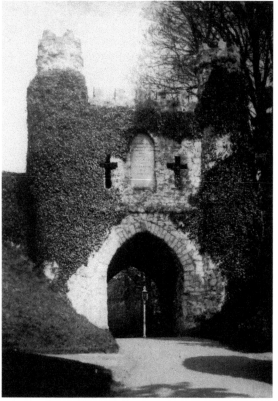

Reigate Castle

How much of Reigate Castle survived, and for how long? The top illustration (copyright of Surrey History Centre), a print of 1785, suggests that quite a lot was still in place in the late eighteenth century. But the illustration actually shows the gatehouse to the castle bailey – illustrated in the photograph from 1933 – which had been built a few years earlier, apparently using most of the old stonework which remained on the site (copyright of Surrey History Centre).

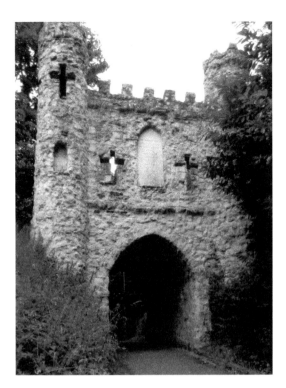

Reigate Castle

The gatehouse now is not much altered from its appearance in 1933, save for the loss of encrusting ivy. The inscription at the top notes that it was constructed by the proprietor R(ichard) B(arnes) in 1777 and prays that the memory of William, Earl Warren [sic] should 'not be forgotten'.

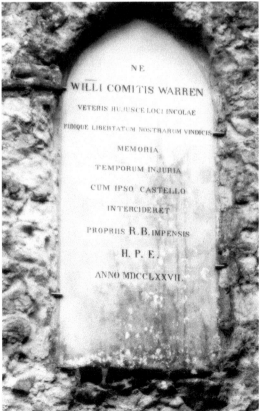

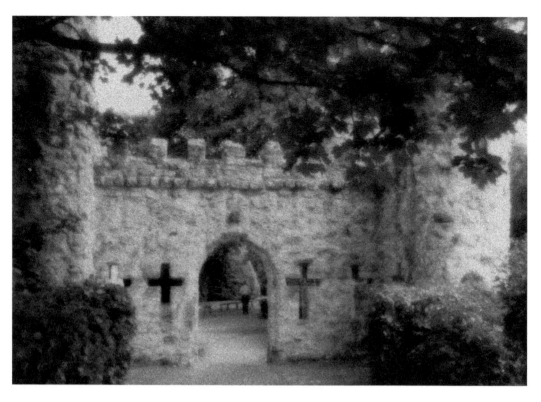

Reigate Castle

There is another, smaller, arch on the castle mound. Perhaps this was also constructed from stones of the old castle? The lower illustration is of the castle bailey. The pyramid is of modern construction and indicates a former exit – or air-hole – for the 'Barons' Cave'.

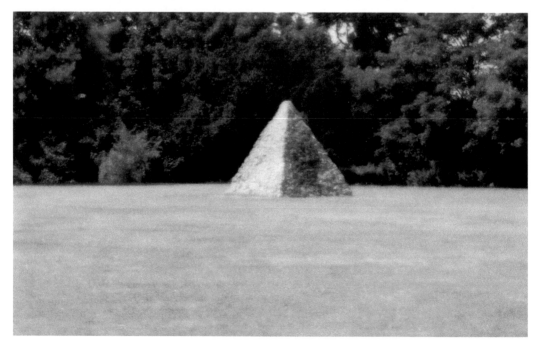

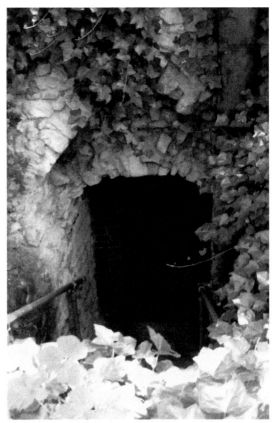

Reigate Castle: 'Barons' Cave'
There is a story, probably false, that a substantial cave underneath the castle grounds had been used by barons plotting against King John in 1215. The top photograph shows the entrance to the 'Barons' Cave'; the bottom photograph shows the interior. Public access is restricted but is sometimes possible through the kindness of the Wealden Cave & Mine Society.

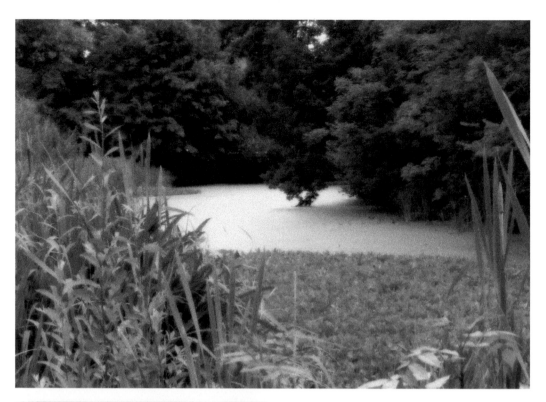

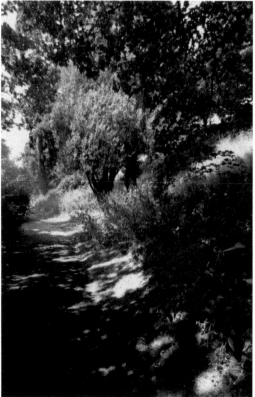

Reigate Castle: Moats
The defensive wet moat (upper photograph) is no longer complete. The dry moat (lower photograph) is closer to the centre of the modern town and also had a defensive function.

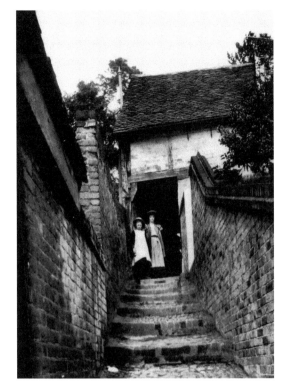

Crown Steps

Steps lead from near the High Street to the castle mound. These steps are often known as the Crown Steps, from the name of a pub which formerly existed at the bottom. The first illustration (copyright of Surrey History Centre) is a photograph from 1900; the second is a modern photograph of the same place. Not much change in a century! The steps were probably used as a cut-through to the north via the castle grounds before the construction of Tunnel Road. The alternative name, Donkey Steps, suggests that the steps were also used by animals, probably carrying burdens.

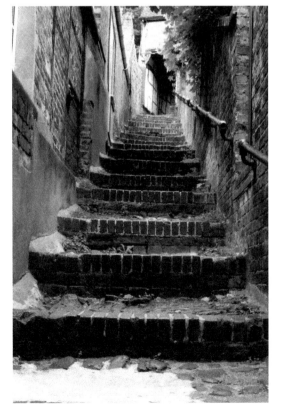

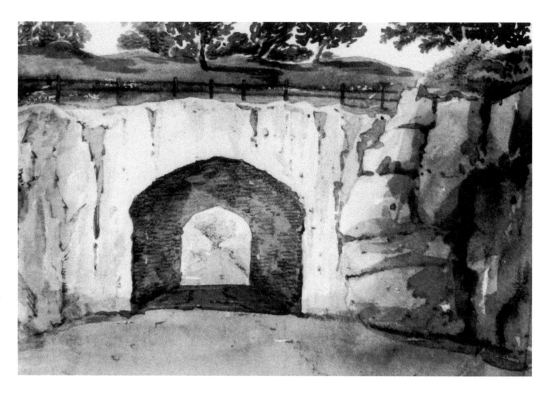

Tunnel Road, Reigate

Tunnel Road is probably the earliest surviving example of a road tunnel driven through an awkward hill in order to facilitate the flow of traffic. The sandstone hill on which Reigate Castle stood forced vehicles travelling from London to Brighton in Regency times to make a detour round the town. Earl Sommers, Lord of the Manor, decided to drive a short tunnel through the rock – and put a tollgate at the end. The top illustration is dated 1823 (copyright of Surrey History Centre), the year of construction. The bottom illustration is modern. The stone on which the earl asserted his rights is still legible atop the brickwork. Happily, the tollgate has long disappeared.

THIS PRIVATE ROAD
WAS FORMED
THROUGH
THE PRIVATE GROUNDS
OF
THE RIGHT HONORABLE
JOHN SOMMERS EARL SOMMERS
IN THE YEAR
M.DCCC.XXIII.

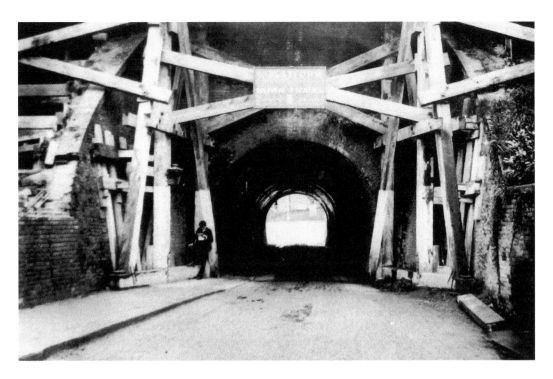

Tunnel Road, Reigate

At times the tunnel has required the attention of repairers, as the top illustration, dated *c.* 1900, suggests (copyright of Surrey History Centre). As the modern photograph shows, it is still functional. Today it is normally confined to pedestrians, but the separation of pavement and roadway is a reminder that this was not always the case.

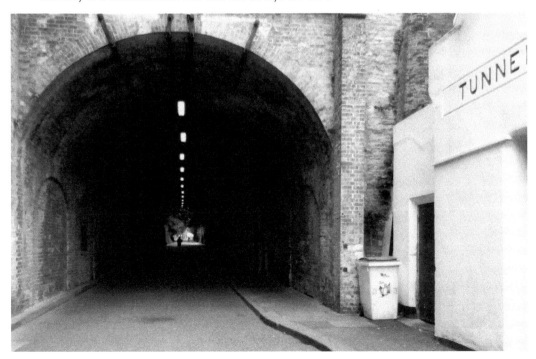

Tunnel Road, Reigate
The southern exit of the tunnel, and Bell Street beyond, may be viewed from the castle mound. On one side of the tunnel is a nineteenth-century ironwork sign which does not refer to current use, but is relevant to its rather surprising history.

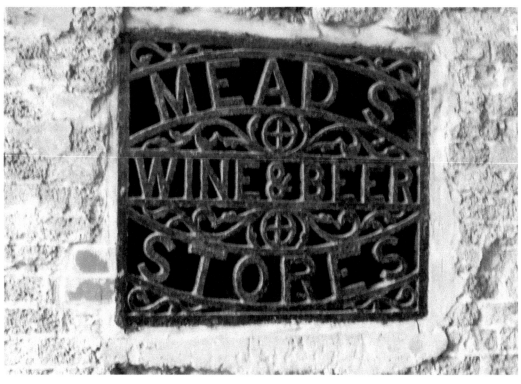

Caves in Tunnel Road

The sandstone through which the tunnel was driven is of variable composition. In places the grains in the rock are of pure white silica and this kind of sand was useful for various functions, including glass-making, scouring floors and scattering in old fashioned pubs. In the few decades which immediately followed the opening of the tunnel, extensive excavations into the sides took place to extract this valuable sand. These excavations were evidently operated by people knowing a lot about mining engineering, as the shape of the profile suggests. There are many marks on the walls and ceiling, made by the tools of excavators. The caves are occasionally made accessible to the public by the Wealden Cave & Mine Society. The top photograph shows a typical cave. The bottom photograph shows initials carved into the wall – the date 1862 corresponding roughly with the end of the sand excavations.

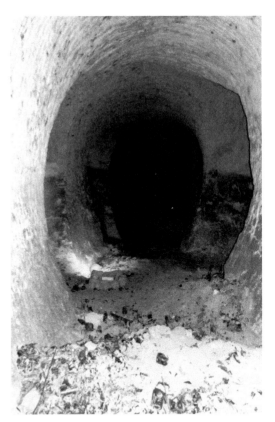

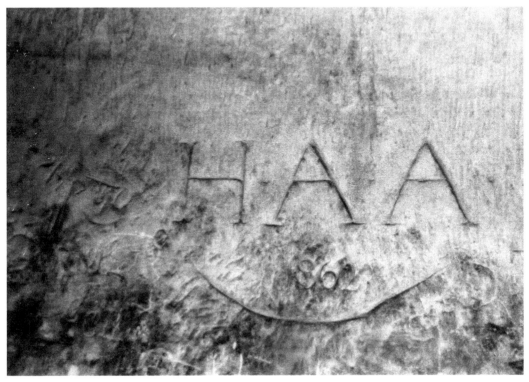

Caves in Tunnel Road

After sandstone excavations ceased, the caves were used by various local bodies, including a cycling club and a rifle club. As the ironwork sign on the wall of the tunnel already noted suggests, they provided a convenient place for storage of beer and wine at an even temperature. The top photograph illustrates that use. During the Second World War, the caves served as an air raid shelter, while they were also used as a post for air raid wardens. The bottom illustration is a mock-up illustrating that use.

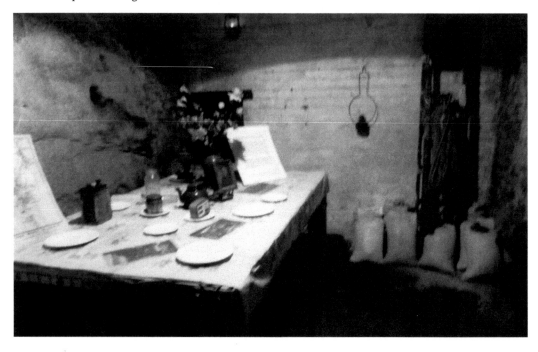

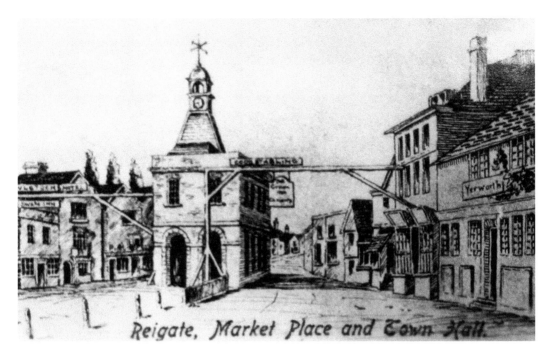

Reigate, Market Place and Town Hall.

Old Town Hall, Reigate

Since around 1728, the Old Town Hall, with the marketplace underneath, has been a familiar landmark to residents and visitors to Reigate. In nearly three centuries it has attracted the attention of innumerable artists and photographers. The top illustration is a sketch, probably from the early nineteenth century (copyright of Surrey History Centre). The second is a photograph from 1886 (copyright of Surrey History Centre).

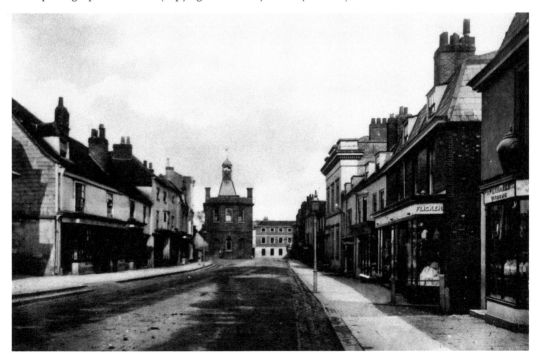

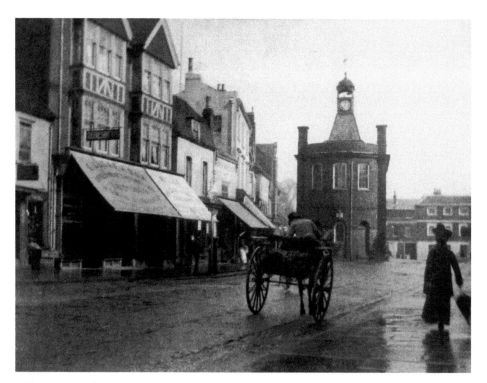

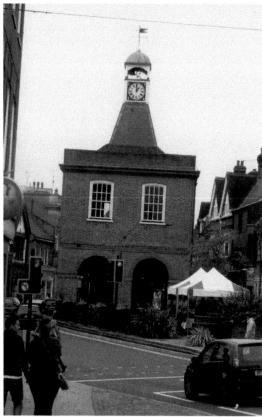

Old Town Hall, Reigate

The Old Town Hall, Reigate, is still familiar when viewed from the west in a photograph taken on a wet day in 1905 (copyright of Surrey History Centre) and when seen from the east in 2015. It is now, deservedly, a Grade II Listed building. The functions however have changed greatly. It is no longer the administrative centre of the town, but the premises of a branch of Cafè Nero.

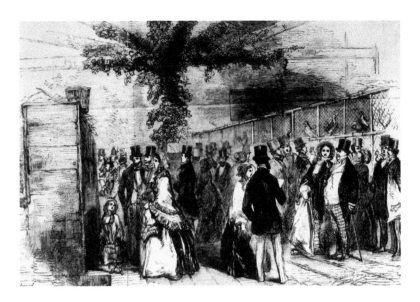

Developing Reigate

The improvement in communications which was brought about by the railway soon resulted in Reigate developing activities which required support from outside the town. The poultry show of 1853 illustrated in the top sketch (copyright of Surrey History Centre) could hardly have been held a decade earlier. The notice shown below (copyright of Surrey History Centre), and dated 1859, foreshadowed a big change in local administration which followed a few years later, when Reigate was incorporated as a borough. It was divided into two wards – the west corresponding roughly to modern Reigate, and the east to Redhill. Relations between them were not always harmonious; at one point it was said that a resident of what later became known as Redhill would not be served in a Reigate pub.

NOTICE.

Having received a Requisition requesting a Meeting of the Inhabitants of Reigate to be called, to take into consideration the propriety of taking measures for constituting the Parish of Reigate a Municipal Incorporation, I hereby convene a Meeting of the Inhabitants of the TOWN AND FOREIGN for the aforesaid purpose, at

THE TOWN HALL,

On THURSDAY, 22nd instant,

At half-past Seven in the Evening.

THOMAS MARTIN,
Bailiff.

15th September, 1859.

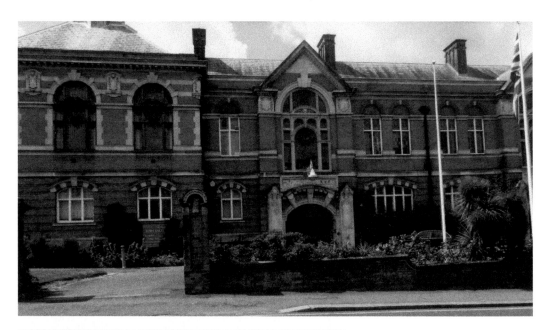

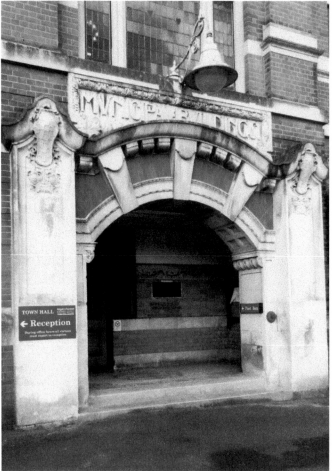

Reigate: Modern Town Hall

A considerable time elapsed between the incorporation of Reigate in 1863 and establishment of an adequate municipal centre. There was much argument about where it should be located. The growing size of the town and the increasing administrative duties of local government necessitated a much larger building than before.

The present town hall, constructed in Arts Crafts style, was opened in 1901. Originally it also functioned as the town's fire station, police station and law courts. Until 1935 the term 'municipal buildings' was therefore preferred to 'town hall'. In 1974 the local authority area was extended to include Banstead.

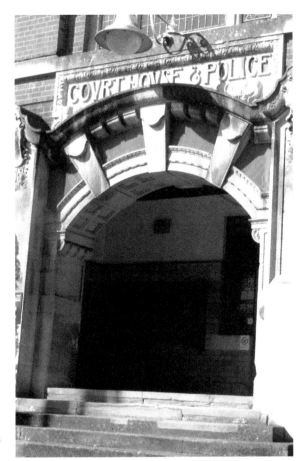

Reminders of the Past

Even the 'new' town hall carries a reminder of the past. One of the entrances signals that it was once also the court house and police headquarters. Not far away is a reminder of a much more distant past. One of the buildings on the adjacent part of the castle mound has features of medieval date.

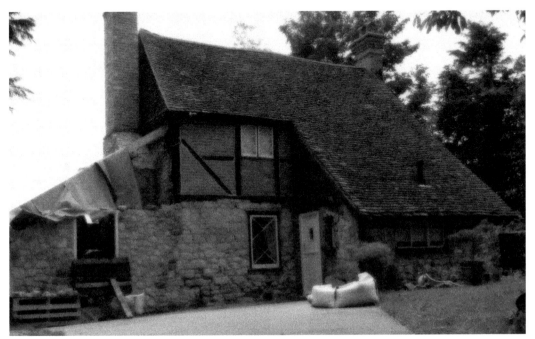

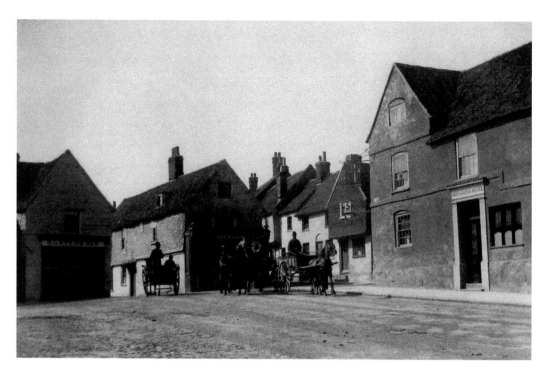

Reigate High Street

As in so many towns, Reigate High Street is the traditional shopping centre. At the west end of the High Street stood – and still stands – the Red Cross inn, whose name long antedates the use of the term for a First Aid organisation. The upper photograph (copyright of Surrey History Tour) shows the Red Cross on the right-hand side, with the name just visible. It was taken before the south side of West Street was pulled down, around 1900. The lower photograph is a modern view of the Red Cross.

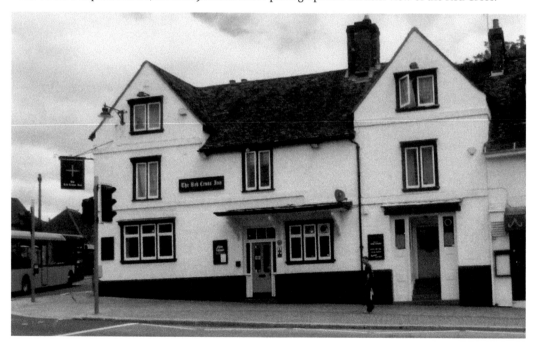

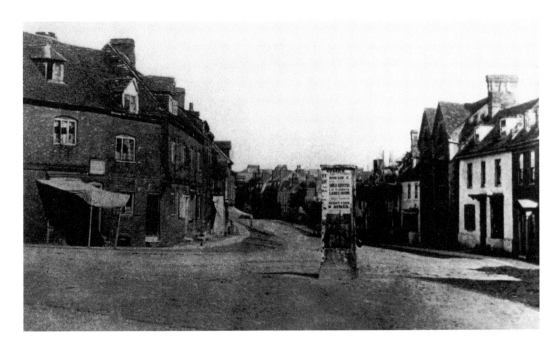

Reigate High Street

In a century and a half, a view of Reigate High Street looking east from opposite the Red Cross has shown many changes, but some of the buildings are still recognisable. The top photograph was taken around 1860 (copyright of Surrey History Centre), at a time when the town centre was still partly residential and the road was apparently unpaved. The bottom photograph is a modern view from the same vantage point.

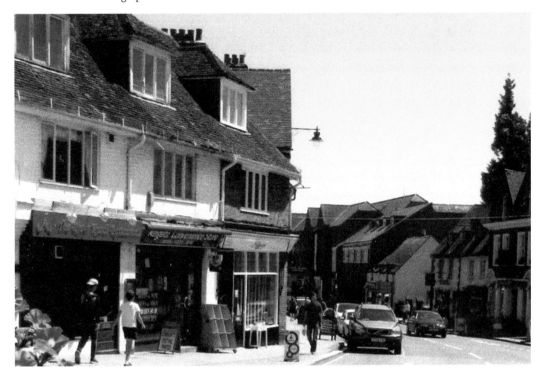

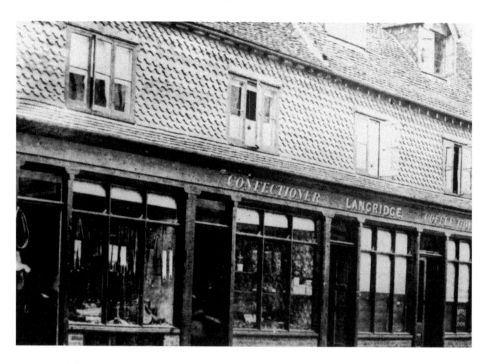

Reigate High Street

Until the nineteenth century was well advanced, Surrey was a rather poor county and shops in Reigate High Street were not very prepossessing, even by contemporary standards. These two photographs, show shops in the same part of Reigate High Street. The top one (copyright of Surrey History Centre) shows shops, barely recognisable as distinct from residential buildings, which had already been pulled down by 1912. The lower photograph (copyright of Surrey History Centre) shows the same place in 1912, by which time Reigate was considerably more prosperous. The shops look much more modern.

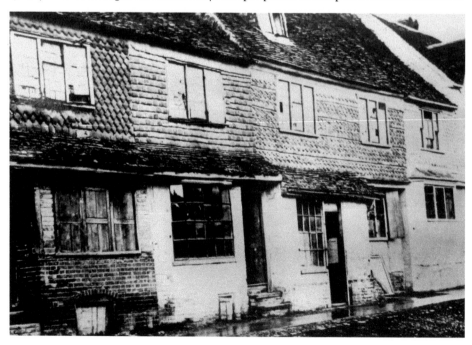

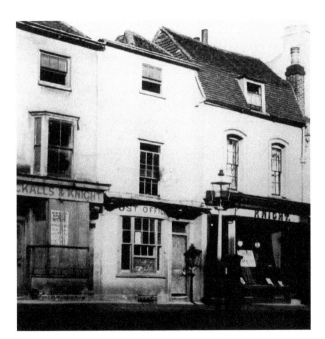

Reigate High Street
At the turn of the twentieth century, Reigate Post Office, situated in the High Street, was almost of a village character, as the top photograph shows. The bottom photograph, taken in a passageway just off the High Street, shows that at least one Tudor timber-framed building is still in active use in central Reigate.

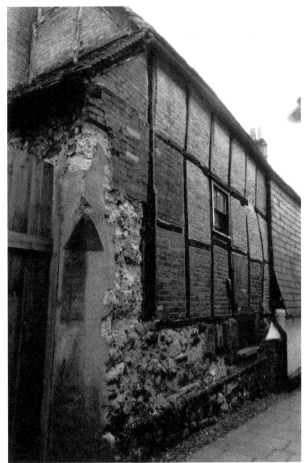

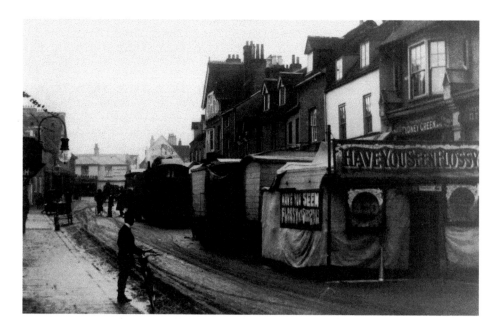

Reigate High Street

In the early twentieth century, Reigate High Street was sometimes used for purposes other than those usually linked with a shopping centre. The top photograph (copyright of Surrey History Centre) shows a fair held there in rather gloomy weather in December 1912. (One wonders who or what was Flossy?) The bottom photograph (copyright of Surrey History Centre) shows an election crowd in the High Street. The people – almost all men, who were then the only voters – are facing the White Hart pub which stood just round the corner in Bell Street. The photograph is not dated, but it must relate to one of the two General Elections held in 1910. Although Reigate was no longer a self-contained constituency, it was the principal town of Surrey South-East, and would have seen the declaration of poll. Some of the voters look anxious, for it was not a safe constituency for any party. It changed hands in 1906, and again in January 1910.

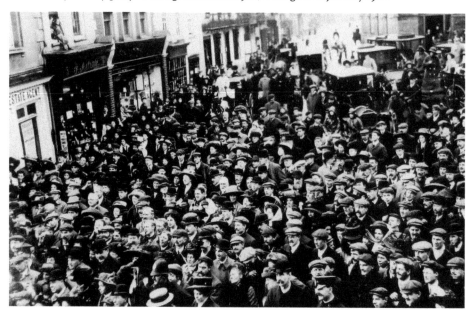

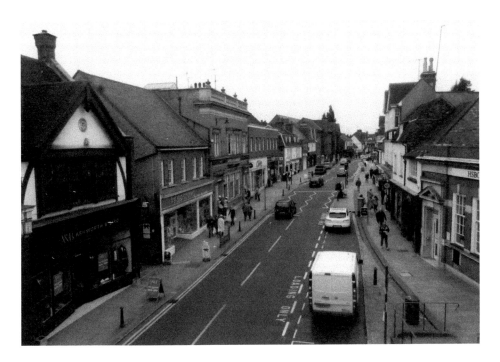

Reigate High Street

Some towns, like Redhill, have changed enormously in the course of the past century. Reigate is very different. There are a few 'chain' shops and banks, but most of the shops in the main street are local. The two photographs on this page were taken from what was once the council chamber of the Old Town Hall and is now the upper room of a café – the first one looking to the west, the second to the east.

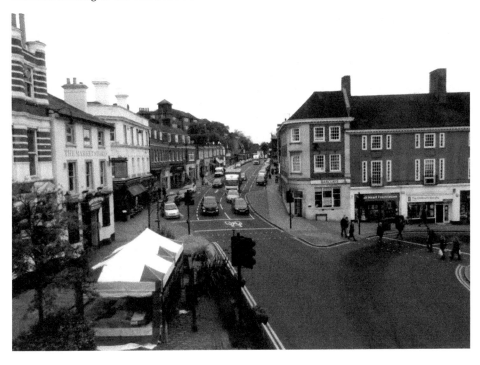

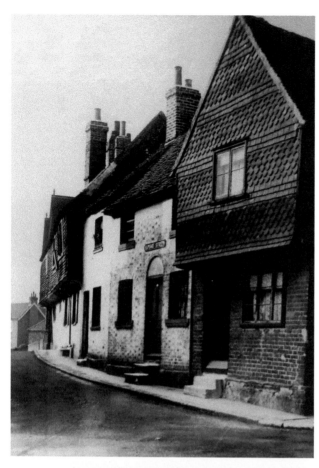

Slipshoe Street

Slipshoe Street is a very short road at the junction of High Street and London Road, opposite the Red Cross Inn. It is steep, and perhaps the curious name was appropriate in earlier times, particularly if it was unpaved, or in wet or frosty weather. There is some attractive old housing. The top photograph (copyright of Surrey History Centre) was taken in the early twentieth century; the bottom one is modern.

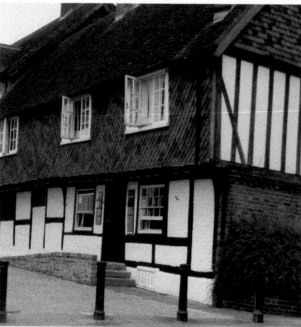

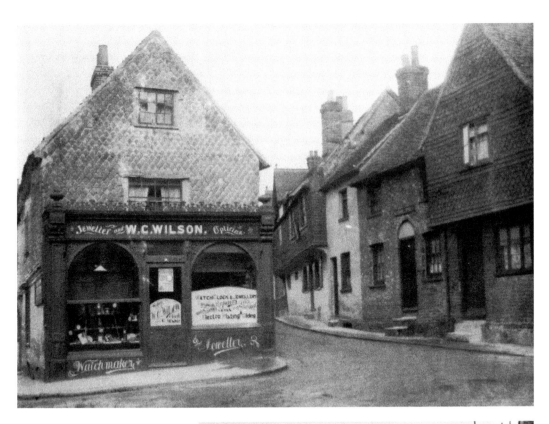

Slipshoe Street

The vicinity of Slipshoe Street has not changed greatly in appearance in more than a century as these two photographs – one of 1904 (copyright of Surrey History Centre), the other modern – confirm. As well as the very attractive ancient buildings are others of a more recent date.

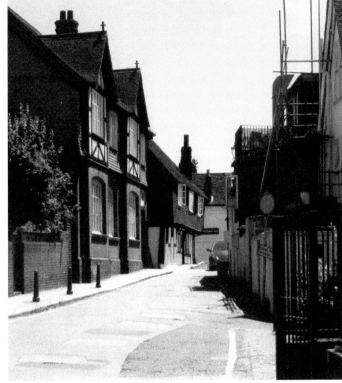

Reigate's Miscreants

Another feature of old Reigate, which has not changed much in appearance over many years, is a building sometimes called 'the Cage' and sometimes 'the Lock-up'. It was originally located in the High Street, but was removed to the end of a short road nearby. It was used in earlier times to hold people who had been convicted by magistrates sitting in the Old Town Hall. These two photographs – the top one (copyight of Surrey History Centre) probably late nineteenth or early twentieth century, the bottom one modern – show its rather grim external appearance.

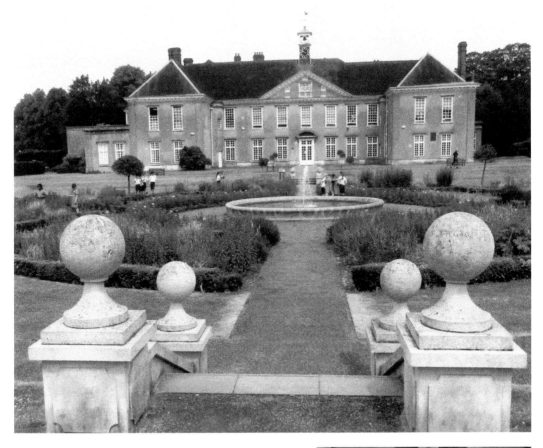

Reigate Priory

The Priory, which is located not far from the town centre, has been an important feature of Reigate's life for many centuries. It was founded in the thirteenth century by one of the earls of Surrey, for use by Augustinian canons. It was seized by Henry VIII during the Dissolution of the Monasteries, and thereafter passed into a succession of secular hands. The buildings are now used as a school, while the grounds are public. The two photographs on this page are modern. The first one shows the very attractive general aspect of the present building in Priory Park. The second shows the armorial bearings in greater detail. These appear to refer to the Tudor phase in its history, although most of the building is of much later date. The bearers are the English lion and the Welsh dragon. The shield shows the English lions quartered with the French fleur-de-lis. Henry VIII still laid (official) claim to the French crown, while the union with Scotland had not yet taken place.

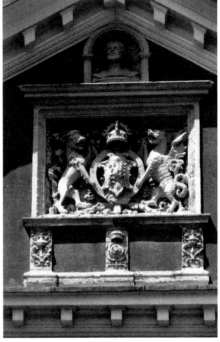

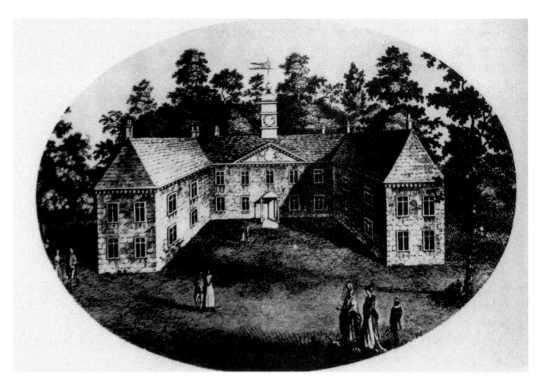

Reigate Priory

The external appearance of Reigate Priory has not changed greatly in the last two or three centuries. A sketch, probably from the late eighteenth century, and a photograph from the turn of the twentieth century show a building essentially the same as the modern structure (copyright of Surrey History Centre).

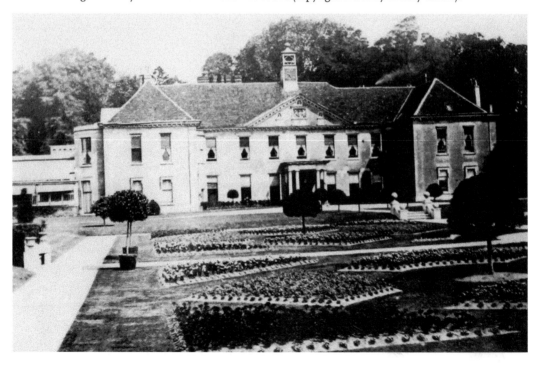

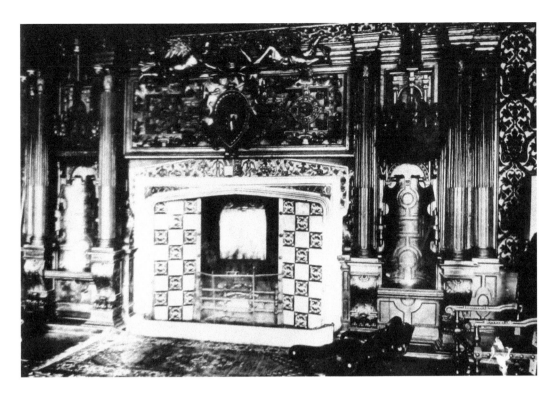

Reigate Priory

When Reigate Priory was in private hands, it showed most of the features usual in an important mansion. The top photograph (copyright of Surrey History Centre) shows the library and hall fireplace at the beginning of the twentieth century. The bottom, modern, photograph shows Monks' Walk. This is a formal walk developed in the late nineteenth century by Lady Henry Somerset. It fell into disrepair but was later restored, with some changes. The name may be appropriate for it leads from the Priory in the direction of the Lake, which monks doubtless used extensively in former times.

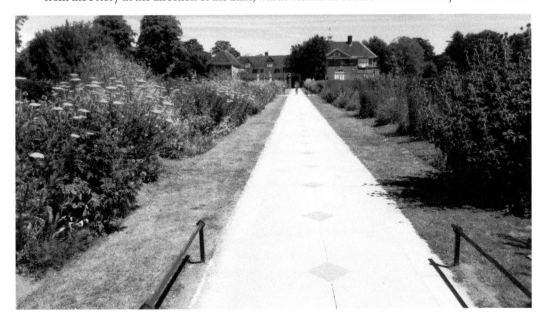

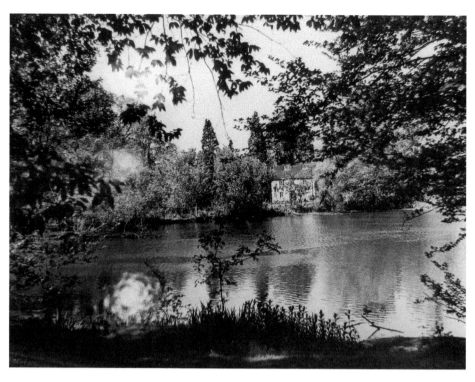

Reigate Priory

Like many monastic houses, Reigate Priory had a substantial lake, which was designed as a source of fish which could be eaten on Fridays and at other fast times. The first photograph (copyright of Surrey History Centre) was taken in 1948; the lower photograph is modern.

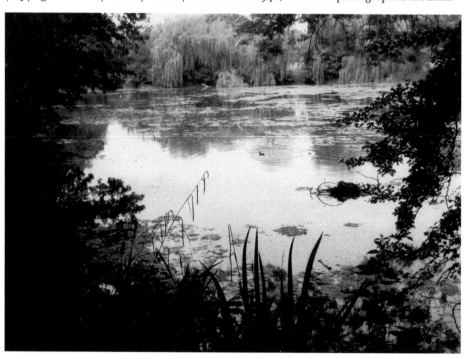

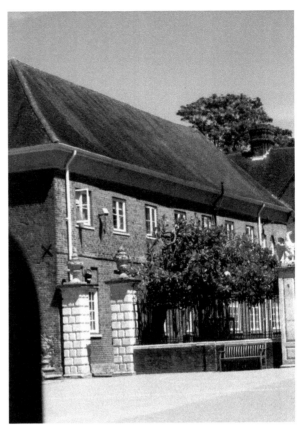

Reigate Priory

At the side of the Priory are gates. Two of these – one to the right of this photograph – are surmounted by eagles. These gates were originally positioned at the entrance to the Priory from Bell Street. At the Bell Street side of the Priory grounds are walls of Tudor date.

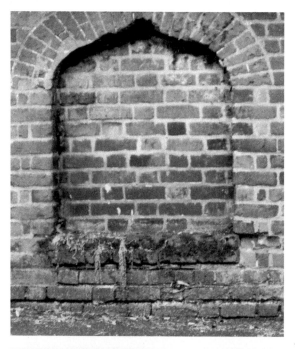

Reigate Priory and Nearby

There are occasional ogee (double S-shaped) arches in the Priory wall. The top photograph shows one of these arches, which may once have been connected with a gatekeeper's lodge, but which is now bricked up. The bottom photograph shows a path in Reigate Park, not far from the Priory grounds. This may have a link with the name of the town, for it has been suggested that the word refers to roe deer which roamed there.

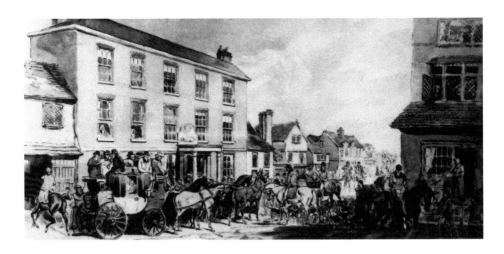

The White Hart

For a great many years, the White Hart Inn was situated near the High Street end of Bell Street. In the days of stagecoaches, and for many years afterwards, the White Hart was an important social centre in Reigate. The top illustration (copyright of Surrey History Centre) is a sketch, probably from the early nineteenth century, showing a stagecoach and also a fox-hunting meet assembled outside. The second illustration (copyright of Surrey History Centre) shows an arch to commemorate Queen Victoria's visit Brighton, shortly after her accession in 1837. Victoria's arrival on the throne was widely welcomed, particularly by people with radical ideas, as a dramatic change from the long succession of unpopular Hanoverian kings, and there was particular relief that it excluded the next in line, her uncle the Duke of Cumberland. Another inn of the same name was later opened in Church Street, but this is also now closed.

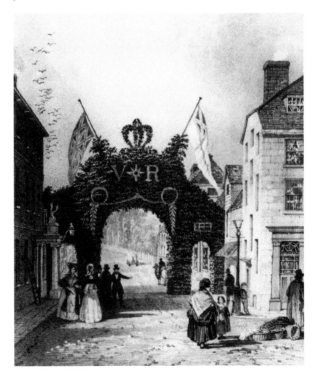

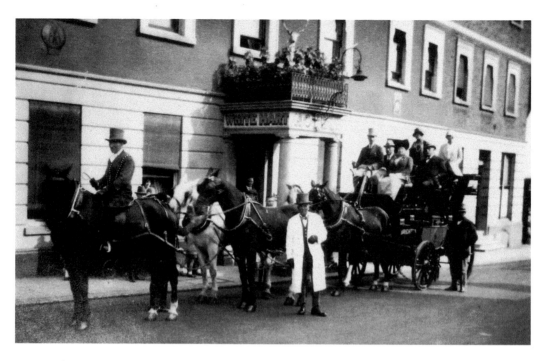

The White Hart

In the eighteenth and early nineteenth centuries, many coaches plied outside the White Hart. The top photograph was originally labelled 'Last of coaches 1906', but it looks much more like a mock-up of a coach, probably in the 1920s. The bottom photograph, dated 1933, shows the White Hart still functional as an inn. It illustrates the White Hart's relation with the tunnel and High Street. Both photographs are copyright of Surrey History Centre.

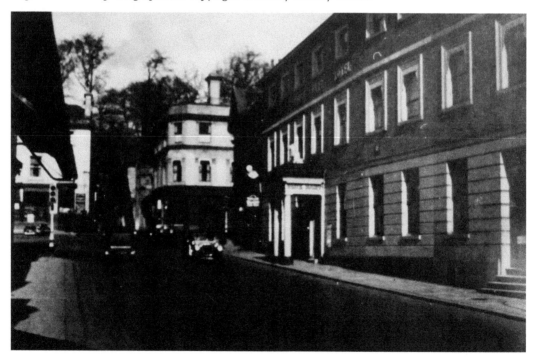

Bell Street

The principal road to the south from central Reigate is Bell Street. Close to the north end stood the White Hart inn; a few doors to the south was the eponymous, and still functioning, Bell Inn, shown in the top illustration. At one time there were many provision shops. The lower photograph (copyright of Surrey History Centre) of a butcher's shop was taken around the end of the nineteenth century and reminds us of the very different standards of hygiene which prevailed at the time.

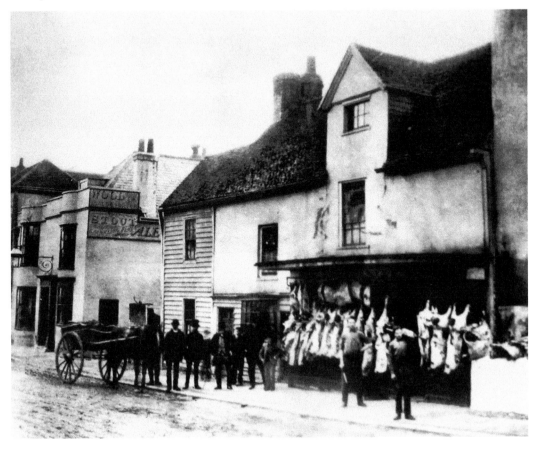

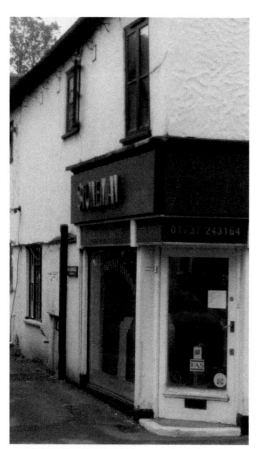

Bell Street

Much of the property in Bell Street is of considerable age. The top photograph shows the premises of Stoneman, a funeral director. When first built in around the Tudor times, it was a hall house – that is, it consisted of a large hall from which smaller rooms opened. When the premises were being refitted in the late twentieth century, a doublet – a padded jacket of the period – was discovered. Remarkably, this was a working garment. It had apparently been put there for superstitious reasons – to ward off evil spirits. The bottom photograph shows a stone in the wall of a much later, but still quite old, building further down Bell Street. The date is significant. It was the year of Waterloo, but it was also in the middle of the Regency period, when many wealthy and fashionable people, with their substantial entourages, travelled through Reigate en route to Brighton. This traffic generated a big demand for workers of many kinds and Reigate was already a growing town.

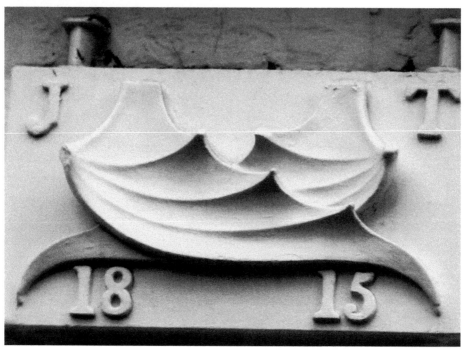

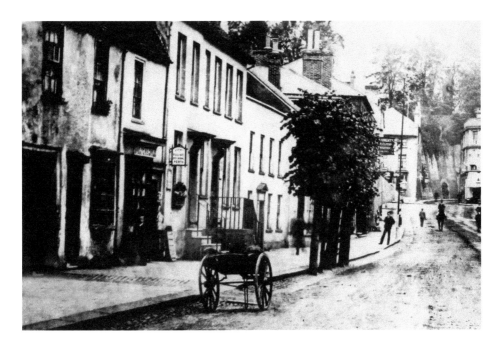

Roads to London

By the turn of the nineteenth and twentieth centuries, when these two photographs were taken, the principal road from London to Brighton no longer passed through Reigate, as it had done in the early nineteenth century. Bell Street (top photograph) and London Road (bottom photograph) were nevertheless important thoroughfares from the capital to the south coast. These illustrations (copyright of Surrey History Centre) remind us how narrow and poorly surfaced important roads still were at the time.

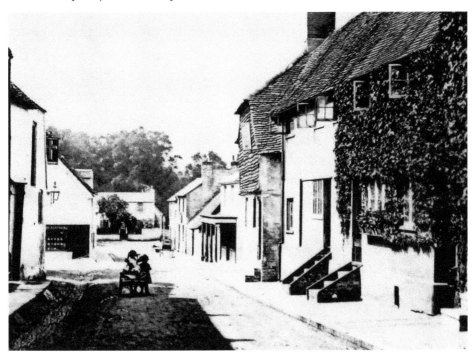

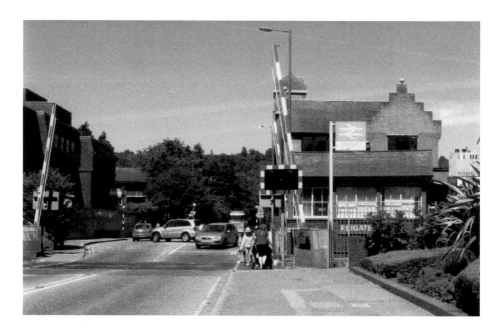

Reigate Station

It would be difficult to overstate the importance of railways to the development of both Reigate and Redhill. As we have noted, Reigate town (for good or ill) missed the opportunity of being on the main line from London to Brighton, but – later in the 1840s – it acquired a station on a west–east line. Although Reigate station was never as important as the one at Redhill, it soon generated big changes. The persistence of a level crossing is, no doubt, a matter of annoyance to motorists, but at Reigate (unlike some other busy road rail crossings) at least there is a footbridge to help pedestrians who are in a hurry. The bottom photograph reminds us that the station only carries one line in each direction.

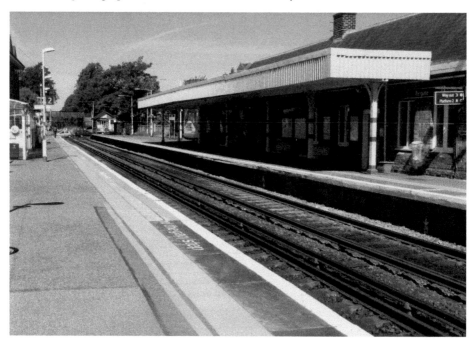

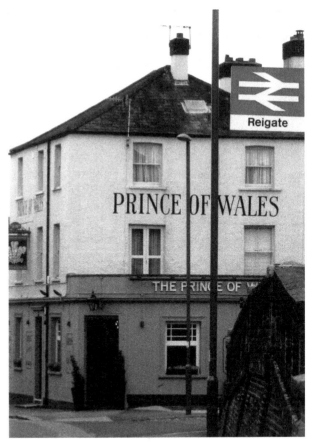

Impact of the Railway

Before Reigate station was opened, there was little development north of the present railway line. Creation of a railway station however almost inevitably implied that a pub should be opened nearby. The Prince of Wales first opened in the 1850s. One part of the pub premises later received the imaginative name 'Platform 3'. Not long after the station was opened, building began immediately to the north – as illustrated by the substantial Victorian houses shown in the lower photograph.

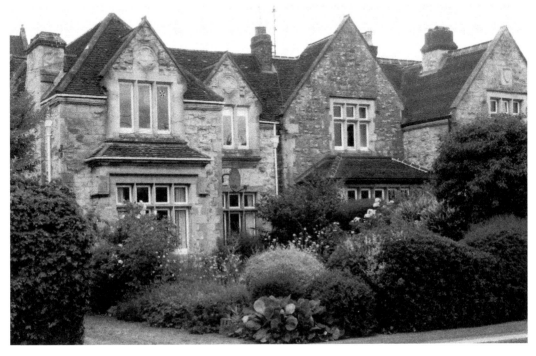

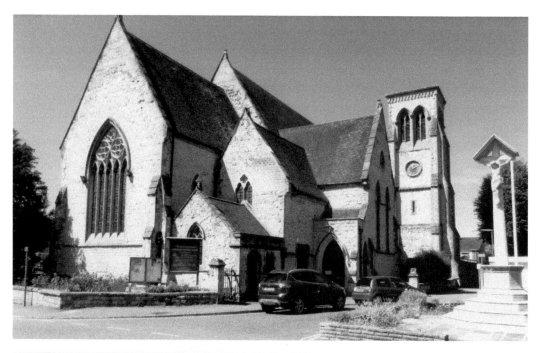

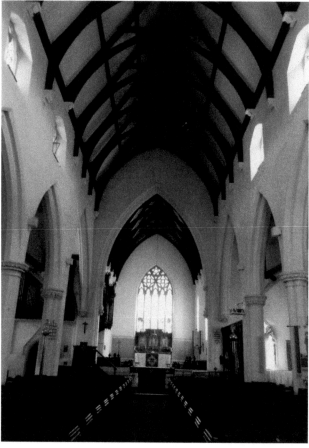

St Mark's Church

As housing developed north of Reigate station in the latter part of the nineteenth century, so also did the demand for a place of worship. The ancient Reigate parish church of St Mary Magdalene was a considerable distance away and new churches were built and new parishes established to serve new communities. St Mark's Church in Alma Road, Reigate, was an early response. It opened in 1860, just over a decade after the railway station.

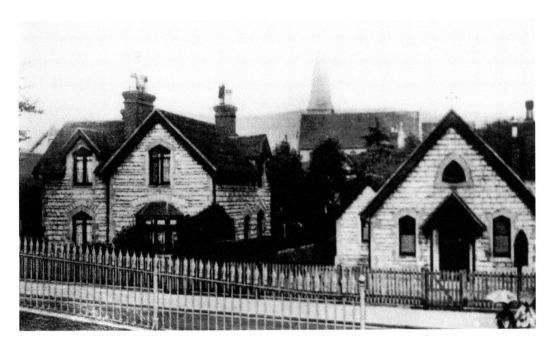

Church Schools in Reigate

Before Forster's Act of 1870 required the establishment of universal elementary education, the function of primary teaching was performed largely by religious bodies. The National Schools operated by the Church of England were the most important of these bodies, although Catholics and nonconformists also set up religious schools in various parts of the country. Some of these church schools still exist, some have been taken over by secular bodies and others disappeared. The top photograph (copyright of Surrey History Centre) is of the schools attached to St Mark's Church in the late nineteenth or early twentieth century. The lower illustration (copyright of Surrey History Centre) is said to portray the National School in West Street, Reigate.

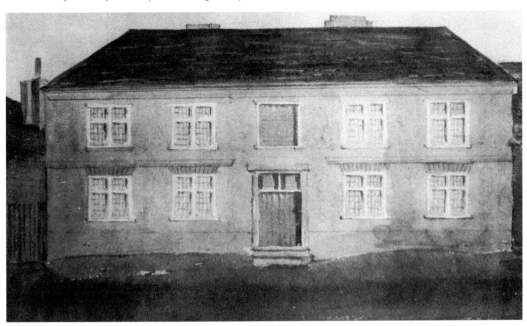

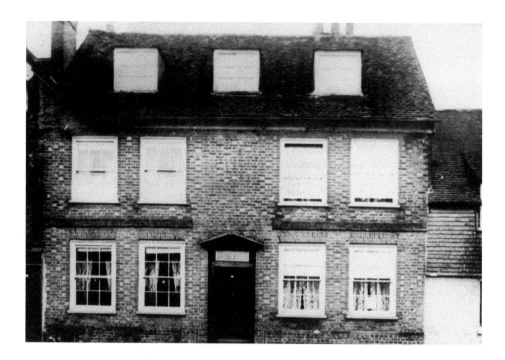

West Street

The National School in West Street, which was shown on the previous page, later underwent transformation into a private house – as shown in the top illustration (copyright of Surrey History Centre), which appears to have been photographed around 1912. West Street, which is a westward extension of High Street, was already beginning to undergo an impressive facelift in the early twentieth century. The bottom photograph (copyright of Surrey History Centre), taken before 1909, suggests that West Street, at the time, was a rather rundown, if picturesque, area – ripe for substantial changes.

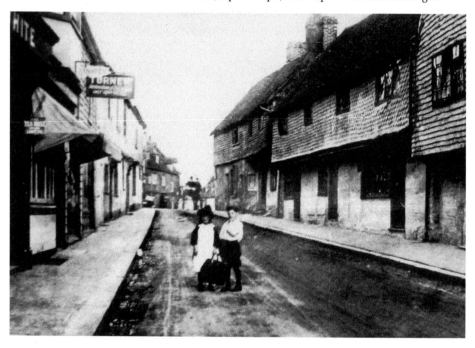

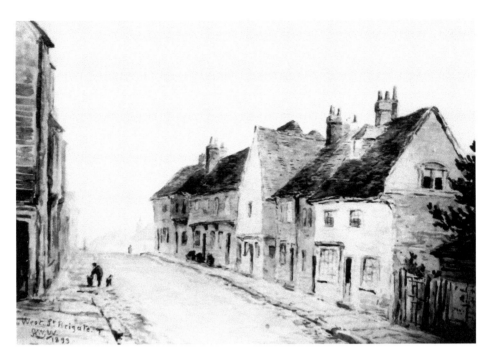

West Street

Two sketches of 1893 (copyright of Surrey History Centre) further emphasise the character of nineteenth-century West Street. The cottages present a delightful picture – but, one feels, they would have been less delightful to live in. The road outside them appears to be unpaved, though it is part of the present A25 leading to Dorking and Guildford. Between the arrival of the motorcar and the much later creation of the M25, it was the most important east–west road in Surrey.

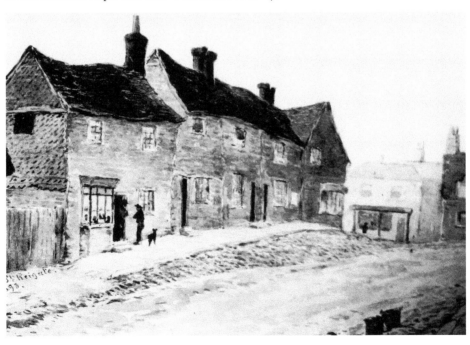

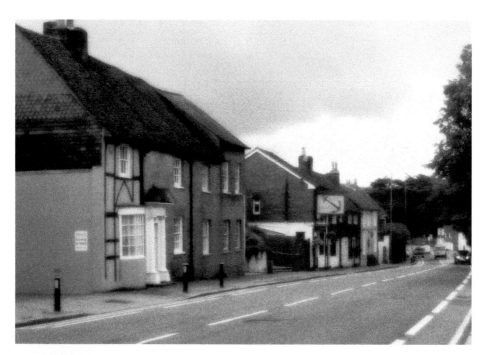

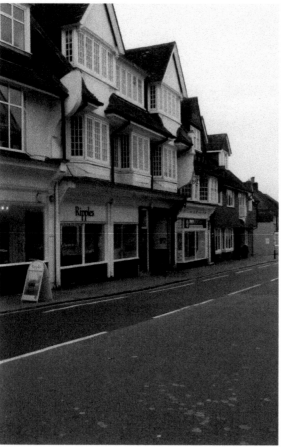

West Street

Today, the character of West Street has changed almost beyond recognition, as these two photographs show. Though most of the east–west traffic is now carried by the M25, the A25 is an important and busy road, lined by properties – houses and shops – some built in the twentieth century and some in the twenty-first century.

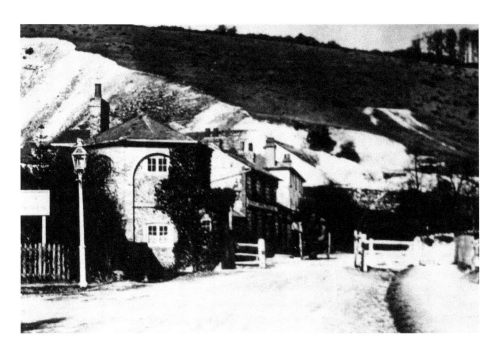

Reigate Hill

The modern A217 runs northward from Reigate in the direction of Sutton and London. In much of the nineteenth century it was a turnpike road which carried a considerable volume of horse-drawn traffic from Brighton to the capital. It ascends the very steep scarp slope of the North Downs and one feels pity for the horses, drivers and passengers who made the hazardous journey in either direction, particularly in bad weather. The photograph (copyright of Surrey History Centre) shows the tollgate near the bottom of the hill in the nineteenth century. The sketch at the bottom (copyright of Surrey History Centre), based on a watercolour of 1881, shows a slightly romanticised view of the same scene. It brings out sharply how very rural the road still was, for the man driving cattle evidently had little to fear from traffic. A large chalk quarry may be seen in the background. Chalk was often used for marling fields, and for firing as a source of lime and cement.

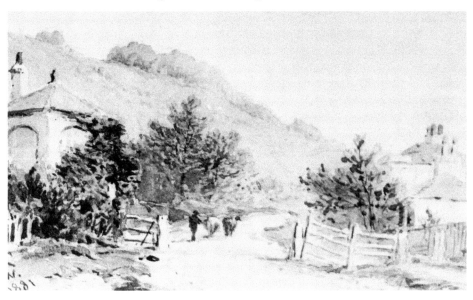

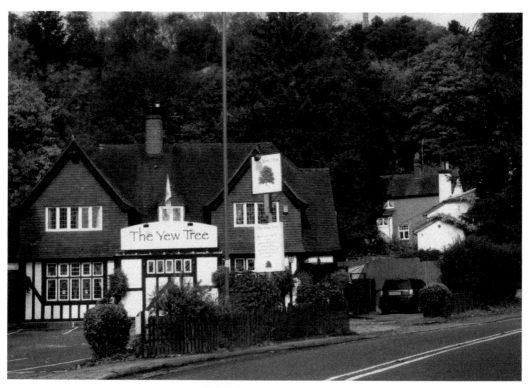

Reigate Hill
The Yew Tree Inn is not far from the site of the old tollgate, and the old quarry, now much overgrown, may be seen in the background. The bottom photograph shows some late nineteenth- or very early twentieth-century buildings nearby.

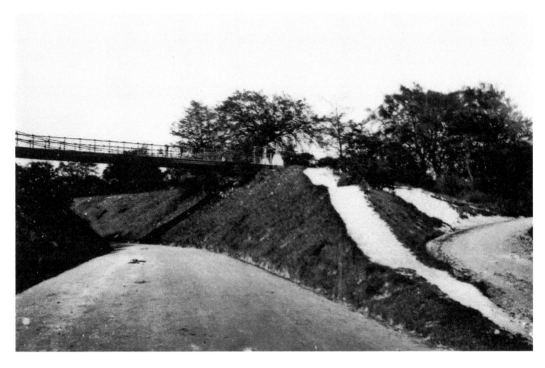

Reigate Hill

Near the top of Reigate Hill, the road is crossed by a footbridge which carries the North Downs Way. Constructed in 1910, it is the earliest British example of a footbridge constructed of reinforced concrete. The top photograph is probably from the early twentieth century (copyright of Surrey History Centre). The bottom photograph shows a similar scene today.

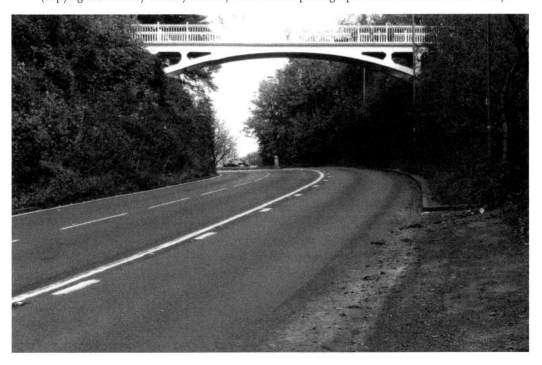

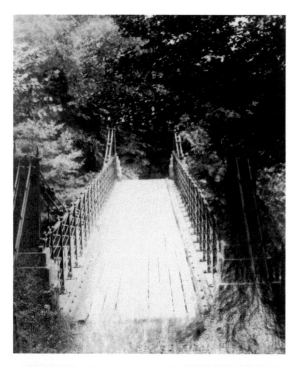

Reigate Hill
The footbridge has been strengthened in recent years. The top photograph (copyright of Surrey History Centre) was probably taken in the early twentieth century. The second shows some structural improvements made in the present century.

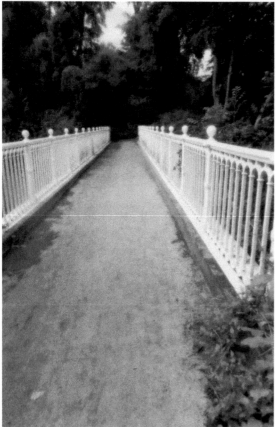

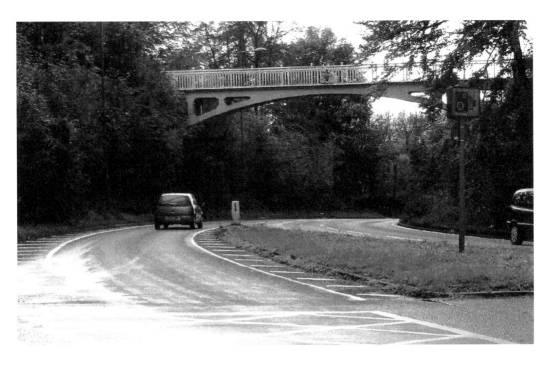

Reigate Hill
When seen from the north, the footbridge crossing shows another road joining the A217. The bottom photograph is taken from the modern viewpoint near the top of Reigate Hill, with Reigate town visible in the distance.

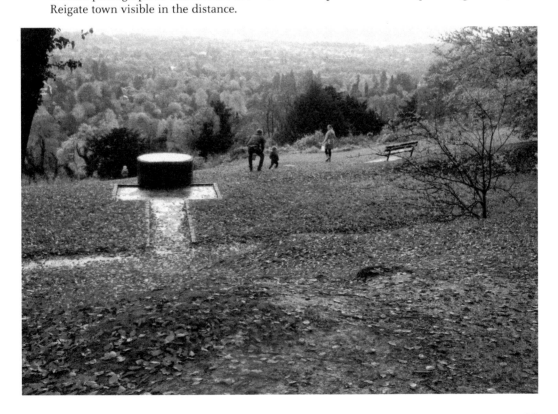

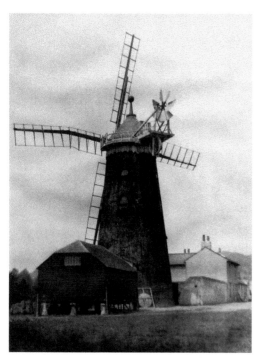

Windmills

The Reigate area did not have much flowing water, but parts were exposed to strong winds. So the usual way of grinding grain was by windmills. Once there were several of these. The top photograph (copyright of Surrey History Centre) shows a windmill on Wray Common. The image below (copyright of Surrey History Centre) shows the Blackborough Mill before 1875. Often when the sails were damaged, it was not considered economic to repair them and the mill fell into disuse.

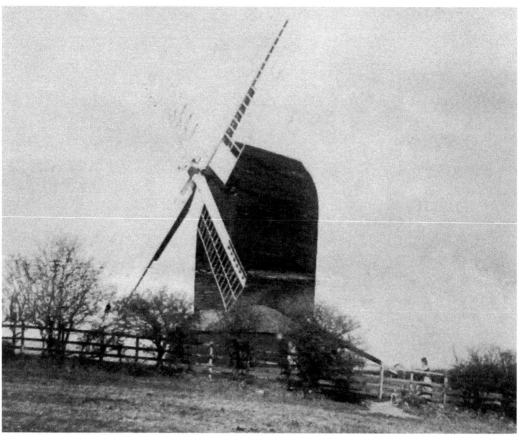

Quakers in Reigate

To the annoyance of some Anglicans in the town – including the otherwise enlightened early eighteenth-century vicar, Andrew Cranston – not all Reigate residents cared to communicate with the Church of England. A Quaker Meeting House, illustrated in the top sketch (copyright of Surrey History Centre), was established at an early date. As the below photograph shows, the Quaker presence continues and there is a modern Meeting House near where the old one once stood. At one time. Quakers would have been refused burial in the grounds of the parish church and a separate burial ground was made. Tombstones may be seen to the left of the meeting house.

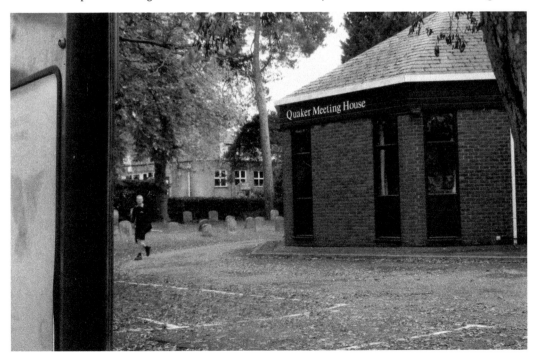

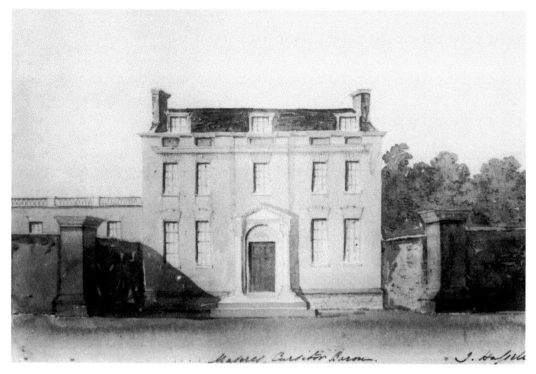

Maseres, Cursitor Baron. J. Hassell

Great and Small in Church Street

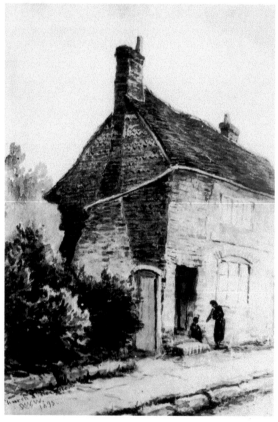

An important building in Church Street which has undergone some changes of use is The Barons, illustrated by a sketch of 1827 (copyright of Surrey History Centre). Built in the early eighteenth century, it acquired its name from its long occupation at the turn of the eighteenth and nineteenth centuries by Francis Maseres (1731–1824). Maseres became a Baron of the Exchequer – a judicial post. He also played an important part in the administration of Quebec, and was a mathematician of some note. The lower illustration (copyright of Surrey History Centre) is a sketch of 1893, showing old cottages in the same road.

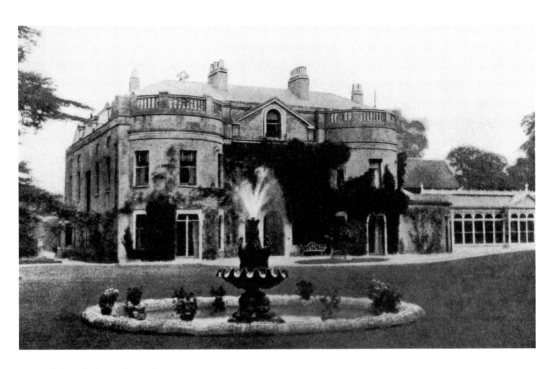

Other Reigate Mansions

Reigate Priory and The Barons were not the only large residences in the town. The top photograph (copyright of Surrey History Centre) is of Great Doods, whose name is commemorated in modern thoroughfares. The lower photograph (copyright of Surrey History Centre) shows Colley Manor House, whose owners eventually dedicated a large part of their property to public use.

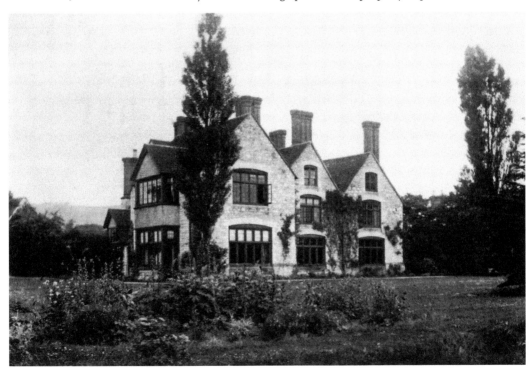

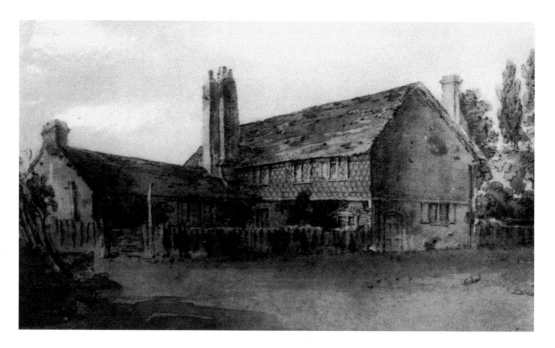

Reigate Grammar School

Reigate Grammar School has had a remarkable and very varied history. In origin it was not a grammar school at all – either in the old sense of a school teaching rudiments of Latin for aspirants to the learned professions, or in the later sense of a selective school. It began with a bequest of 1675, and for much of its early life the vicar of St Mary Magdalene Church was also master of the school; a common practice in town schools. By 1720 its regular pupils were down to 'four poor boys' whose curriculum, we may guess, was probably no more advanced than a mixture of the 'Three Rs' and some religious teaching. By 1823, the school – variously known as the Grammar or Free School – was evidently larger than that and occupied the building shown in the top illustration (copyright of Surrey History Centre). In 1862 it was reformed as a grammar school; the old building was demolished and new ones erected. It was still quite small and at that time had thirty-six pupils. The bottom photograph (Reigate Grammar Archives) shows the school in 1870, viewed from the church tower.

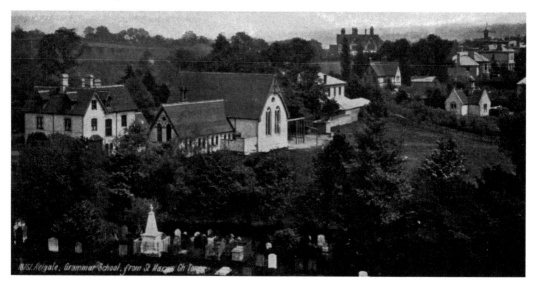

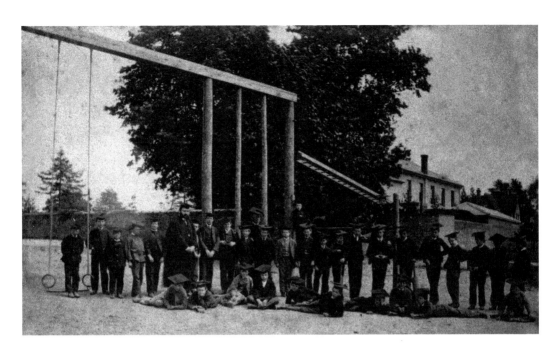

Reigate Grammar School

There are many records of the school's past, only a few of which can be seen here. The top photograph (copyright of Reigate Grammar School Archives) shows a group of boys with a master in around 1870. The bottom photograph (copyright of Reigate Grammar School Archives), taken from the school's 1910 prospectus, shows a typical classroom of the period, with desks bearing hinge-top lids and inkwells.

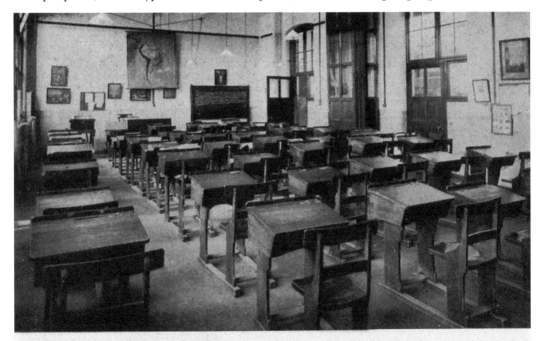

ROOMS 2 & 3.

REIGATE GRAMMAR SCHOOL.

Reigate Grammar School

When Butler's 1944 Education Act took effect, Reigate Grammar School was brought under Surrey County Council as a selective grammar school within the state system. A decade or so later, comprehensive schools became all the fashion, and Reigate Grammar School faced a real danger of closure. The governors decided that the only safe way of keeping the school in existence was by 'going private', which it did in 1976. In the same year another important change took place and girls were admitted to the sixth form. In 1993 they were admitted throughout the school. Today it has well over 1,000 pupils of both sexes, drawn from a wide catchment area.

Some features of the school are old: the top photograph is of a building from 1907, still in use. Others are new. The large science block shown in the lower photograph is a recognition of the importance of science in modern education. Science laboratories existed in the school a century ago, but science teaching was much less prestigious than it is today.

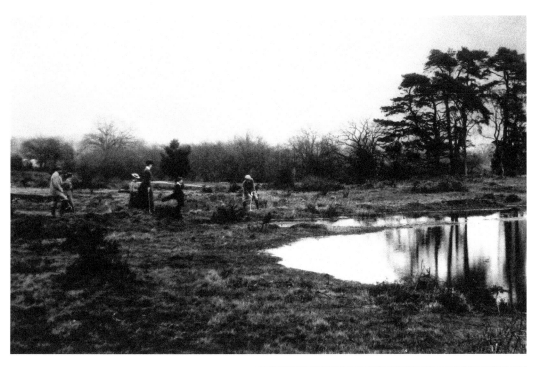

Reigate Heath

Reigate Heath, west of the town, has long been a venue for visitors. The top photograph (copyright of Surrey History Centre) is from the early twentieth century. Similar scenes might be seen today although the fashions may have altered over the years. One of the most remarkable features of the area is the Mill Church, which was built into the structure of a windmill (copyright of Surrey History Centre).

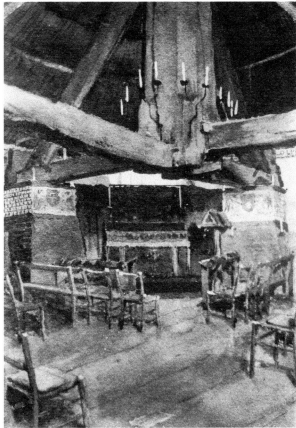

Two More Reminders of the Past

Modern Reigate shows features which at one time would have been almost universal in towns, but are today less often seen. Once, shoe scrapers like the one observed in Bell Street were common outside houses and other buildings. Today they are less common, for roads are less muddy, horse droppings are less frequent and dog owners are more scrupulous with their pets. Drinking fountains, like the one observed outside the Old Town Hall, were also common. They were designed to furnish refreshment for the thirsty traveller. They had a source of water and a metal drinking-cup on a chain. Drinking fountains were often erected by temperance enthusiasts in the hope that they would discourage people from drinking stronger beverages. Today they are seldom functional, for it is considered unhygienic for people to drink from an unwashed cup used by others.

Redhill Common

Before the middle of the nineteenth century, the name 'Redhill' was only applied to Redhill Common, which is some distance from the centre of modern Redhill. It is an attractive open space, featured in these two photographs. The use of the name Redhill for the whole district turns on a curious accident. Around the 1840s, a sub-post office was established in the vicinity of the common, and letters were franked 'Red Hill'. In the 1850s the office was moved to a more central position in the developing town, but the name continued to be used for postal purposes. Eventually, it came into general use for the whole town.

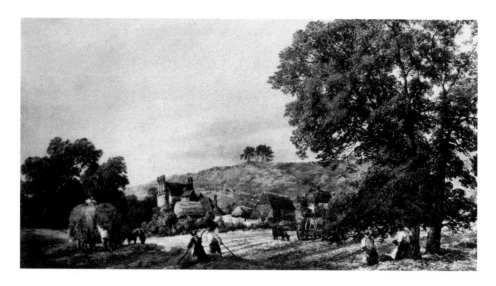

Old Garlands

Until the 1840s, the place which is now called Redhill was just a part of a rural area usually known as 'Reigate Foreign'. The top illustration, copyright of Surrey History Centre, is based on a watercolour of around 1825 by Charles Davidson, portraying a scene at Old Garlands farm, Mill Street, not far from present-day Brighton Road. That scene is somewhat imaginative; but the modern reader is struck by the large number of people engaged in the work. Agriculture was highly labour-intensive, and labour was plentiful and cheap. Farm labourers were ill paid everywhere, but particularly in the south of England, where there was little alternative work for the poor and illiterate. Old Garlands farmhouse, visible in the middle distance, is also shown in the bottom photograph. It is a building much altered over time. The basic timber-framed structure probably dates from the sixteenth century. What is now visible – including the nineteenth-century dormer gables – is much more recent.

Old Redhill

Scattered around the area of modern Redhill are a number of buildings which date to before the time when development began. Fengates House, in the top photograph, looks like a substantial farmhouse, or even a small manor house. Carter's Cottages in King's Avenue appear to derive from the late seventeenth or early eighteenth century. They were designed for farm workers and provide an instance of the accommodation which some benevolent farmers or landowners offered to their employees. No doubt there were also many bad cottages, but those have long disappeared.

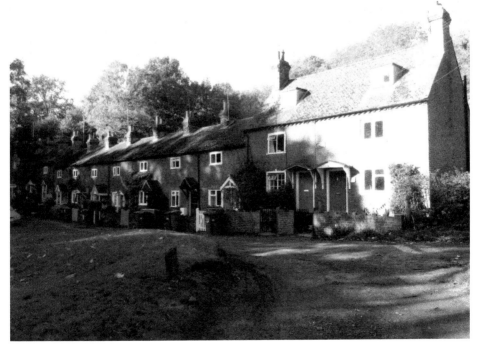

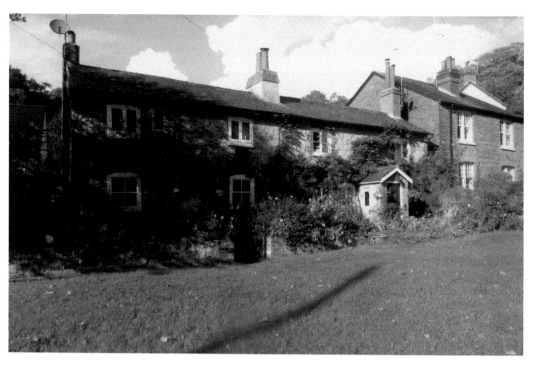

Old Redhill

Several other groups of better-class cottages remain which date from before nineteenth-century development began in the Redhill area. The top photograph shows cottages in Pendleton Road; the bottom photograph shows others in Linkfield Lane.

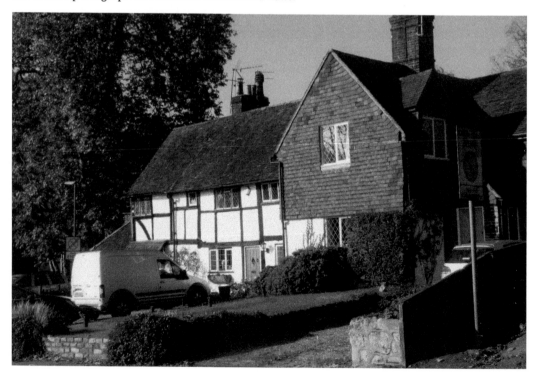

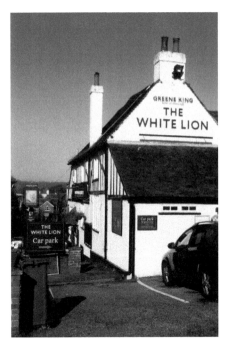

Old Redhill

The White Lion inn, at the corner of Linkfield Street and Grovehill Road, has been altered considerably in recent times, but it retains ancient structures and has been in continuous use since long before development began in the area.

The bottom photograph, probably from the late nineteenth century and copyright of Surrey History Centre, shows an old house nearby. The arched structure at the bottom right-hand side of the house looks like a stable.

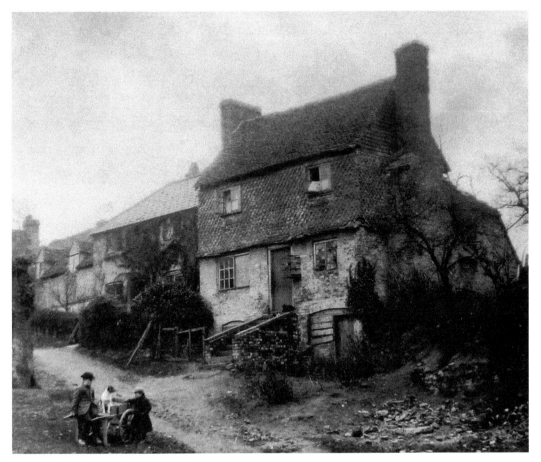

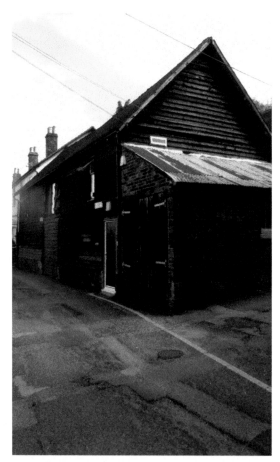

Old Redhill

There was little industry in Redhill before the nineteenth century. One of the few exceptions was tanning, an occupation which was notoriously associated with evil smells. A tannery which once existed in and near Oakdene Road has long disappeared, but a barn which may have been used for storing hides has been successfully converted into a dwelling house. In around 1730, small workhouses were established for Reigate Borough and Reigate Foreign. Provision was later made for groups of parishes to be linked together in 'unions'. Following this arrangement, a much larger workhouse was built in 1794 for Reigate Union, a little south of Redhill Common in what was called Union Road, now Pendleton Road. (lower image copyright of Surrey History Centre).

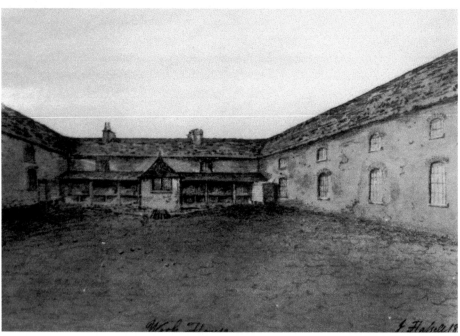

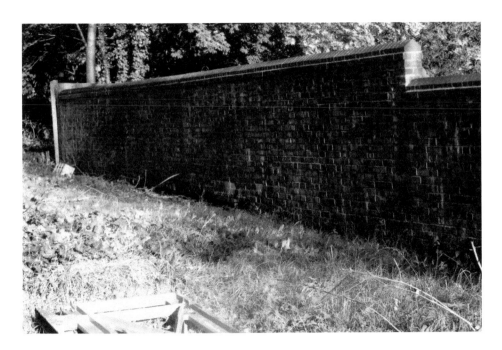

After the Workhouse

During the interwar period, the old workhouses became Public Assistance Institutions, with very different duties towards inmates. In 1936 the site of what had originally been Reigate Union Workhouse was occupied by Redhill County Hospital. The main building of the former workhouse no longer exists. Parts of the old workhouse wall remain, and are shown in the top photograph (copyright of Surrey History Centre). The porter's lodge and another building were built in the early twentieth century and are shown in the foreground of the bottom photograph (copyright of Surrey History Centre). The site of the main building has been developed as a housing estate, part of which may be seen in the distance.

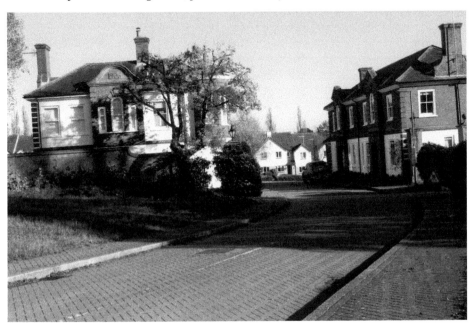

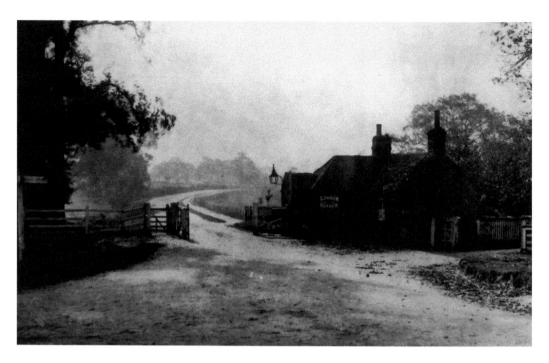

The Way to the Workhouse

People travelling from the centre of Reigate to the Union Workhouse in the nineteenth century would probably have passed down Bell Street and its continuation, Cockshot Hill, and then turned into Woodhatch Road, where they would have encountered a tollgate. Two views of this tollgate, both probably from the late nineteenth century, are shown in the photographs on this page. The scene was still very rural.

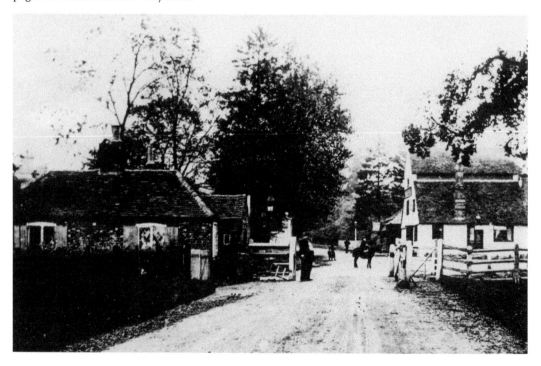

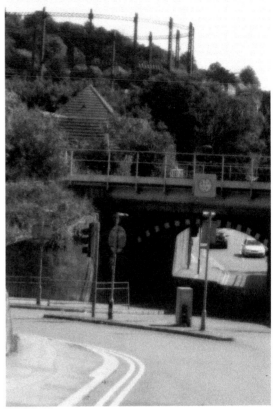

Redhill Begins to Change

The coming of the railways was of enormous importance in the development of Redhill. When the London & Brighton Railway began to build its line, many workmen were brought temporarily into the area. When the line began to operate in 1841, two stations were opened: Battlebridge Lane, a little under a mile south of the present Merstham station, and what was originally known as Redstone Hill & Reigate Road, close to where the railway crosses what is now called Hooley Lane – roughly the place indicated in the top photograph – which is well to the south of present Redhill station. The bottom photograph shows the stationmaster's house in 1845 (copyright of Surrey History Centre).

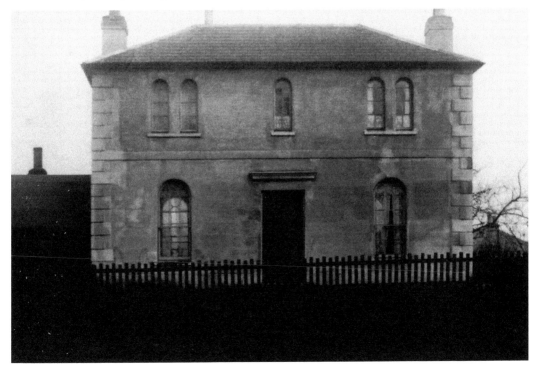

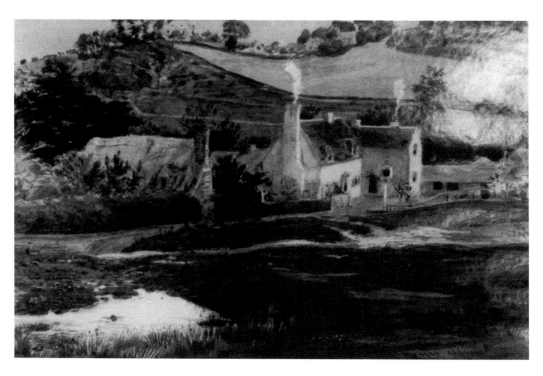

Redhill Begins to Change

Thirsty travellers required a pub, and the Marquis of Granby in Hooley Lane supplied their needs. The top photograph (copyright of Surrey History Centre) shows the Marquis of Granby around the turn of the twentieth century. The bottom photograph is a modern view of the same pub in a much changed form.

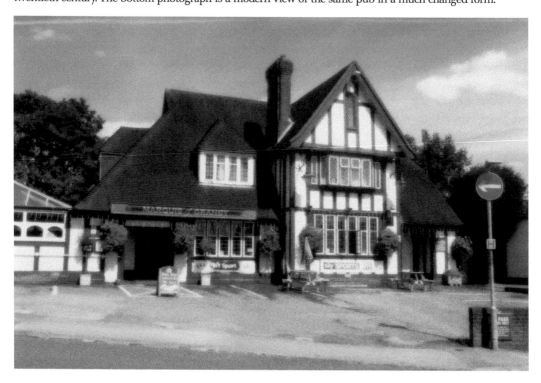

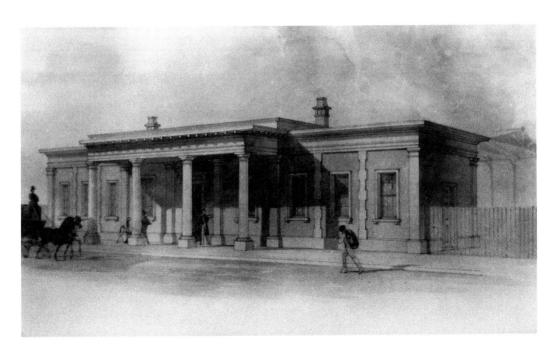

Redhill Begins to Change

In 1842, the year after the London & Brighton station was opened, the South Eastern Railway opened a line from Redstone Hill eastwards to Tonbridge and later Ashford. In 1849 a line was constructed westwards, which eventually extended to Reigate, Dorking, Guildford and beyond. For a time only a muddy and ill-lit path enabled passengers to connect from one station to the other, but common sense ensured that a junction was made on the present station site in 1845. This was originally named Reigate, though the name was soon changed. A common practice was to name stations after the nearest town or large village, even if this was several miles away. The top illustration shows the entrance to the junction station in 1860; the bottom photograph shows some of the lines there five years later (both images copyright of Surrey History Centre).

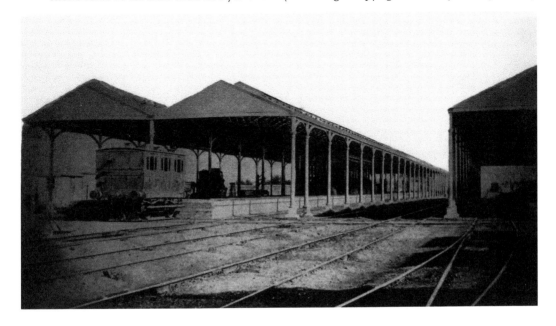

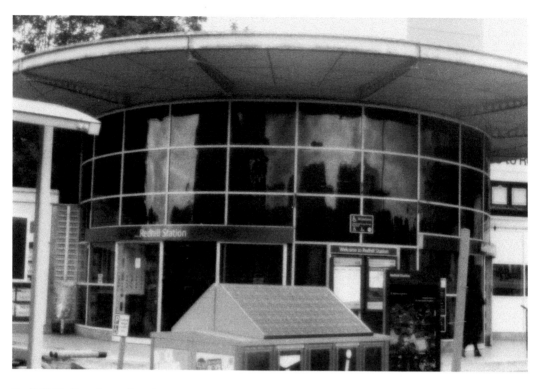

Redhill Station: Later Developments

The main entrance to Redhill station from the west has changed greatly from time to time. The top photograph shows a modern view. The bottom photograph (copyright of Surrey History Centre) shows the eastern approach in 1924.

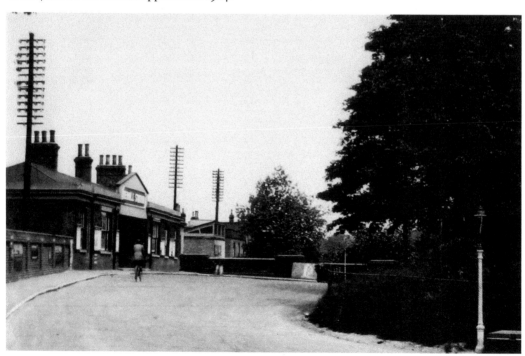

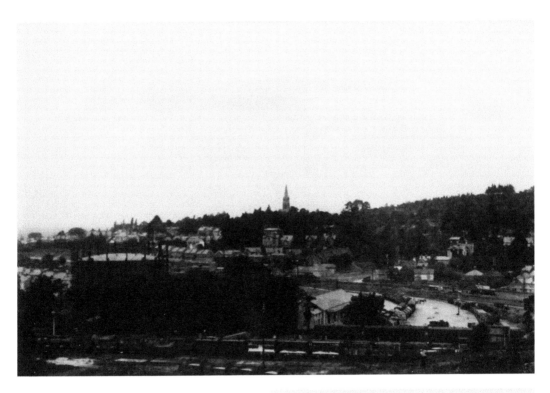

'Little London'

Urban development in what is today called Redhill began in two distinct areas. The nickname 'Little London' was applied to the region in the general vicinity of the original railway station and Redhill Common. The top photograph (copyright of Surrey History Centre) shows how far development, had advanced around 1844, with the railway line in the foreground and the spire of the recently opened St John's Church in the distance. This was originally called Red Hill District Church but soon acquired its dedication to the Evangelist. The bottom illustration (copyright of Surrey History Centre) shows how it appeared in 1855.

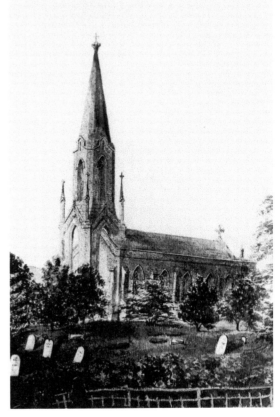

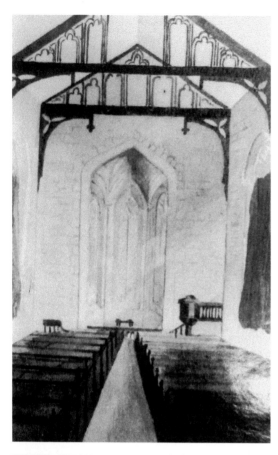

St John's Church, Redhill
The most significant structural change
in St John's Church was the development
of new aisles in the 1860s. The top
photograph (copyright Surrey History
Centre), shows the interior before 1869.
The church's external appearance has not
changed greatly over time, as indicated
by the modern view of the same building.

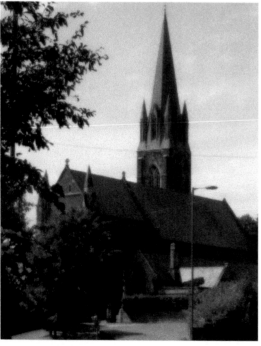

St John's School

When the London to Brighton Railway was built, it occupied what had formerly been common land. The parish sought financial compensation for the loss of grazing and other rights. Two-thirds of the money thus obtained was devoted to the construction of a 'National' – i.e., Church of England – school. This was long before the Education Act of 1870 required the general establishment of what are now called 'State' schools. The top photograph (copyright of Surrey History Centre) shows the original St John's School. This was later replaced by a completely new building, shown in the bottom photograph.

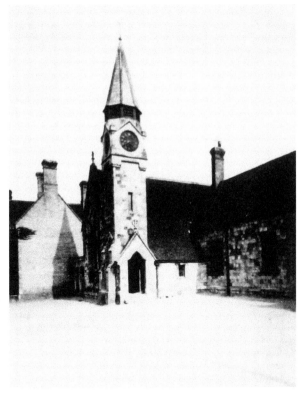

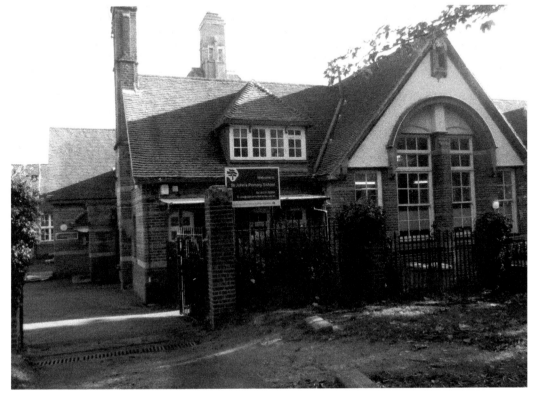

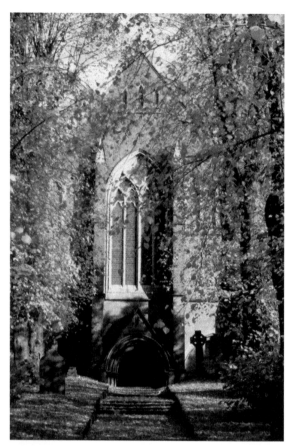

More of 'Little London'
The western approach to
St John's Church, from Pendleton
Road, is perhaps seen at its
best on a sunny day in autumn.
Not far away, a house carrying
the date 1862 reminds us that
development in the general
vicinity of the church continued
even though – as will be seen –
the most extensive changes were
taking place some way to the
north, in what became known as
'Warwick Town'.

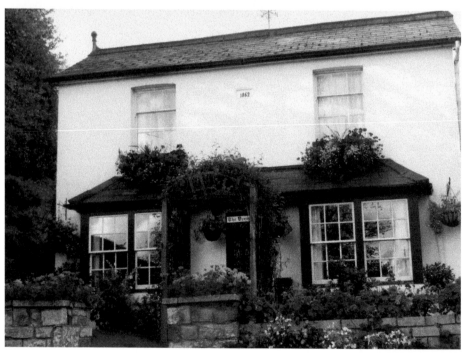

84

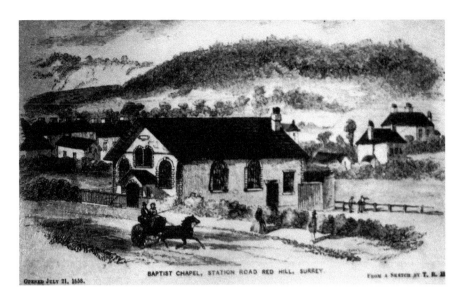

OPENED JULY 21, 1858. BAPTIST CHAPEL, STATION ROAD RED HILL, SURREY FROM A SKETCH BY T. R. M

'Warwick Town'

The development of 'Little London' had been sparked off by the original railway station. When a new junction station appeared further north, another urban development began. Much of the land belonged to Countess Brooke of Warwick and the area was for a time known as 'Warwick Town'. As we have seen, the name Redhill later became general. Many of the old buildings were of poor quality and have long disappeared. An exception was the Baptist chapel in Station Road, which was opened in 1858. The top illustration (copyright of Surrey History Centre) shows the chapel and some of its surroundings not long after it was opened. The bottom photograph is a modern view of the chapel – a building which has changed little, while its surroundings have changed greatly.

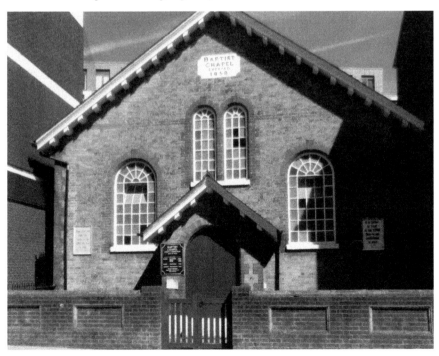

Warwick Town – and Beyond

The name 'Warwick' has been preserved in several places in modern Redhill, which the original countess would certainly not recognise. Warwick Road, seen in the top photograph, is one of those places. But while the main nineteenth-century development of Redhill was taking place in the central 'Warwick Town' area, rather similar changes were seen in a part which bordered on 'Little London'. At the fringe of the two developments there was sometimes a curious mixture of old and new – as seen in the bottom photograph of Linkfield Street in 1887 (copyright of Surrey History Centre).

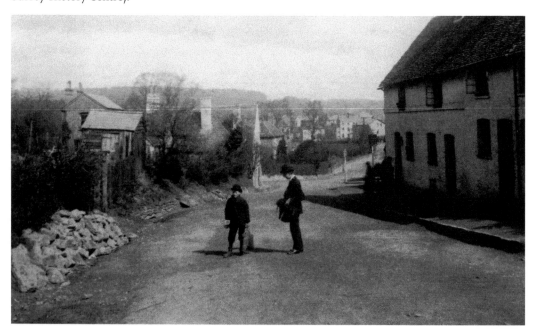

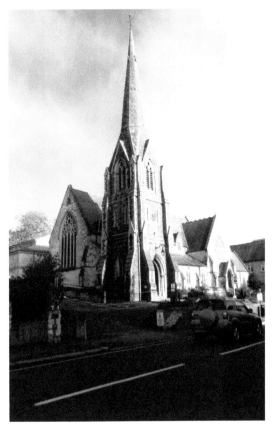

St Matthew's Church, Redhill

Another nineteenth-century religious building in what had been the 'Warwick Town' area of Redhill is St Matthew's Church. As the 'Warwick Town' area developed, it was obvious that the older St John's Church, which had been opened near Redhill Common shortly after the original railway station appeared, was a considerable distance from the part of the new town where most rapid growth was taking place. A temporary 'Iron Church' was set up as a chapel of ease in 1848. It was later replaced by the present St Matthew's Church and a separate ecclesiastical parish was established in 1867. Two modern photographs show different views of the exterior.

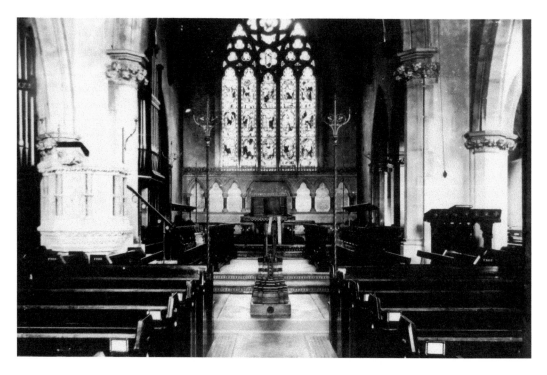

St Matthew's Church, Redhill

The interior of St Matthew's Church has changed little over a long period. The top photograph (copyright of Surrey History Centre) shows a view of around 1890 looking towards the altar and the fine east window. The bottom modern photograph of approximately the same view shows that even the pews have not greatly changed.

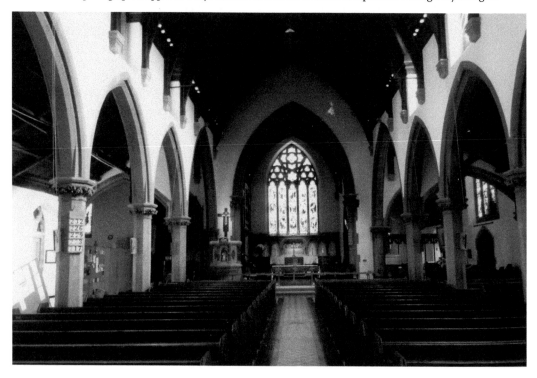

East of the Railway

Soon after the new railway junction appeared at what is now called Redhill, an inn was opened. The 1851 census records the Railway Hotel, with Richard Laker as proprietor. Like many hotels and pubs, it had the rather confusing habit of changing its name. In 1861 it was recorded as Laker's Hotel, ten years later as Junction Hotel and in 1891 again as Laker's Hotel. It is shown in the top photograph, copyright of Surrey History Centre.

Another nineteenth-century development east of the north-south railway was of a very different kind. The Philanthropic Society – later the Royal Philanthropic Society – began its work in London in the late eighteenth century. It was initially concerned to take the children of criminals, or children who had themselves been convicted of crime, and bring them up in a better environment, where they would also be trained in useful work. Agriculture was particularly favoured and so the place was sometimes called the Farm School. Other trades were also encouraged. The school was established in Redhill in 1849. It later became an Approved School and was eventually closed in 1988. The bottom photograph (copyright of Surrey History Centre) shows the school's remarkably ornate chapel, around 1890.

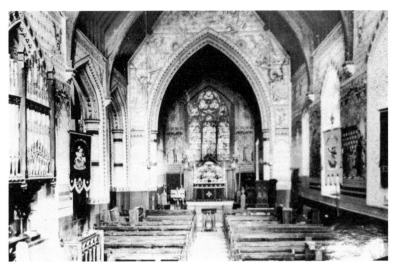

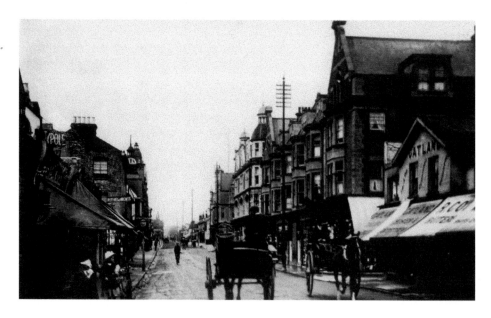

Turn-of-the-Century Redhill

By the turn of the nineteenth and twentieth centuries, the central part of Redhill had changed greatly from the depressing 'shanty town' it had been a few decades earlier, when urban development began. The top photograph is a postcard sent in 1917. The bottom photograph is modern, but shows one of the buildings from the period which remain in use.

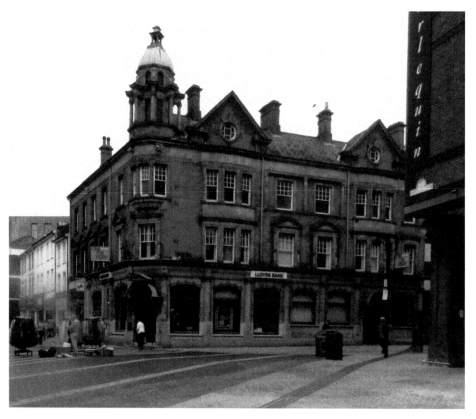

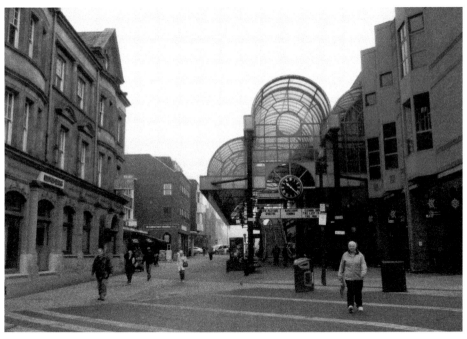

Modern Redhill

In the 1980s and later, the central part of Redhill began to undergo another huge change, becoming an important centre both for shopping and for other activities. Not far from the railway and bus stations is a complex known as Warwick Quadrant – preserving the old name for that part of Redhill. The top photograph shows an outside view at the corner of London Road – now a pedestrian precinct. The bottom photograph shows a street market which is sometimes open in the same area.

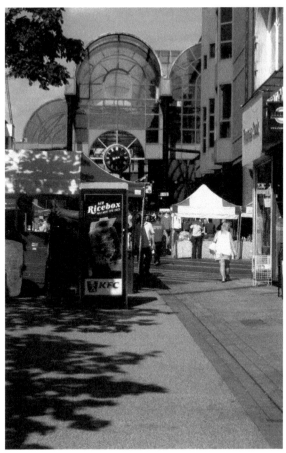

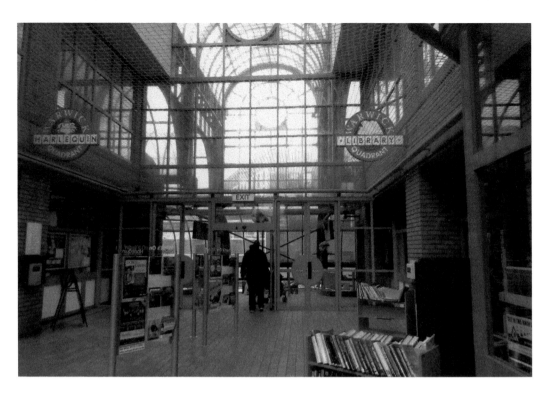

Modern Redhill

Warwick Quadrant brings together different kinds of activity. To the left is the Harlequin theatre; to the right is the town library. Close by the main Quadrant building are Quadrant House, with its remarkable architecture, and Redhill bus station.

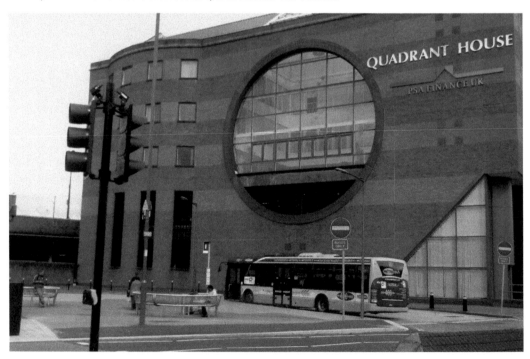

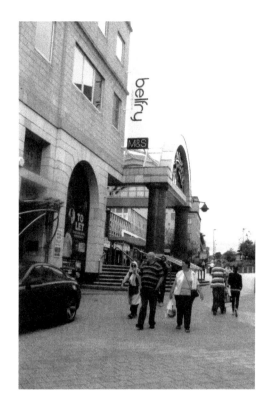

Modern Redhill

An important modern development is the
Belfry shopping centre. The top photograph
shows the entrance from the pedestrian
precinct of Station Road. The bottom
photograph, of the interior, illustrates the
system of lifts and escalators established
for the convenience of shoppers. A contrast
between the centres of Redhill and Reigate
is striking, and one reflects that the radically
different development of the two contiguous
towns appears to derive mainly from the
accident that the leading citizens of Reigate
were reluctant to permit the construction of
a railway with direct links to London and
Brighton.

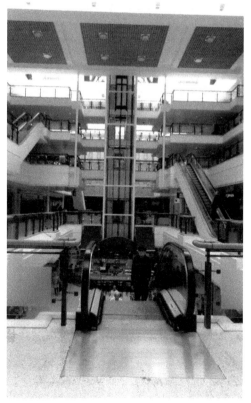

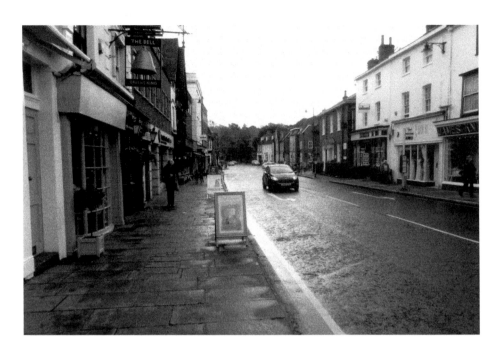

Southbound from Town

The main southbound roads, near the centres of Reigate and Redhill, say much about the history of the two towns. Bell Street, Reigate, in the top photograph, was once part of the principal road from London to Brighton. It was used by George IV when Prince Regent two centuries ago, and by many travellers long before his time. It is lined by buildings of very mixed dates from Tudor times onwards. Not far south of Redhill station is a new road, built to bypass Redhill High Street, which itself only dates from the nineteenth century. The buildings which flank the new road are all very recent, and its southward continuation, Brighton Road, has no building which approaches 200 years old. The road is now part of the A23.

Also Available from Amberley Publishing

This fascinating selection of photographs traces some of the many ways in which Guildford has changed and developed over the last century.

Paperback

180 illustrations

96 pages

978-1-4456-5015-9

Available now from all good bookshops or to order direct please call 01453-847-800
www.amberley-books.com

Also Available from Amberley Publishing

Paperback
96 pages
978-1-4456-3322-0

Available now from all good bookshops or to order direct
please call 01453-847-800
www.amberley-books.com